The Color Book for Funny Cartoons

J. K. Kaguri

All rights reserved by artist.

You do not have rights to redistribute or resell this book to any third party.

Hey, welcome to my book.

Here is a page to try out your materials and coloring techniques!

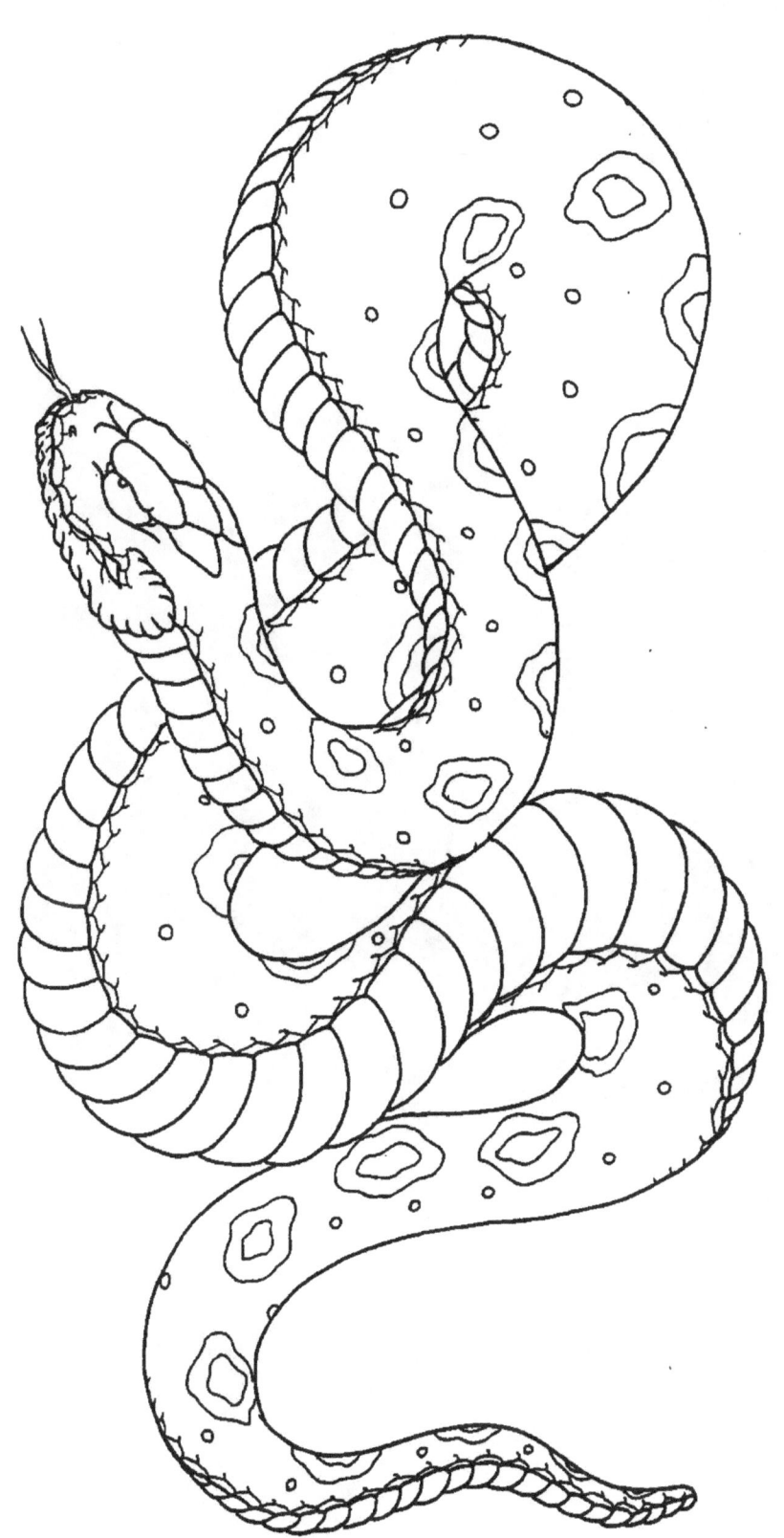

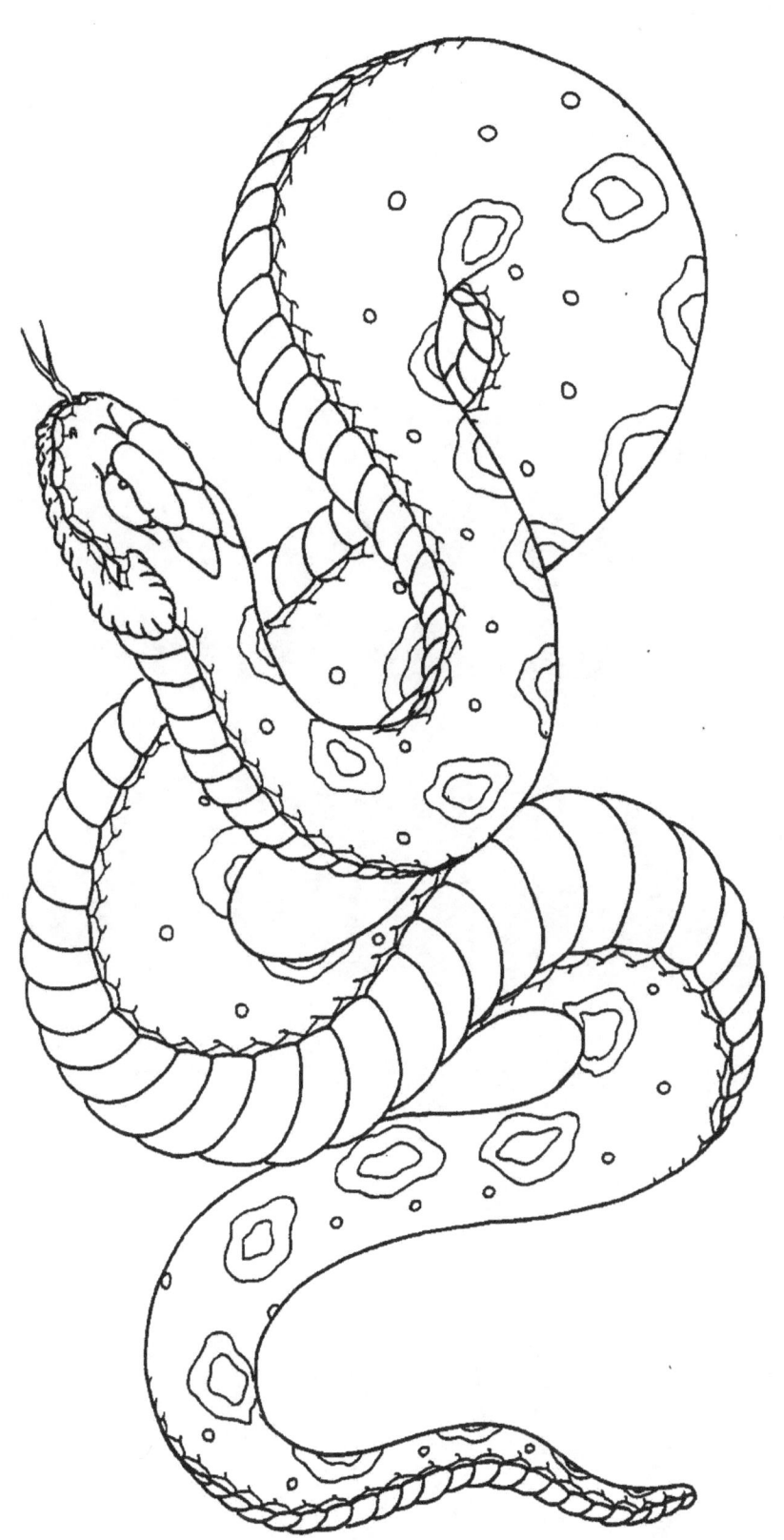

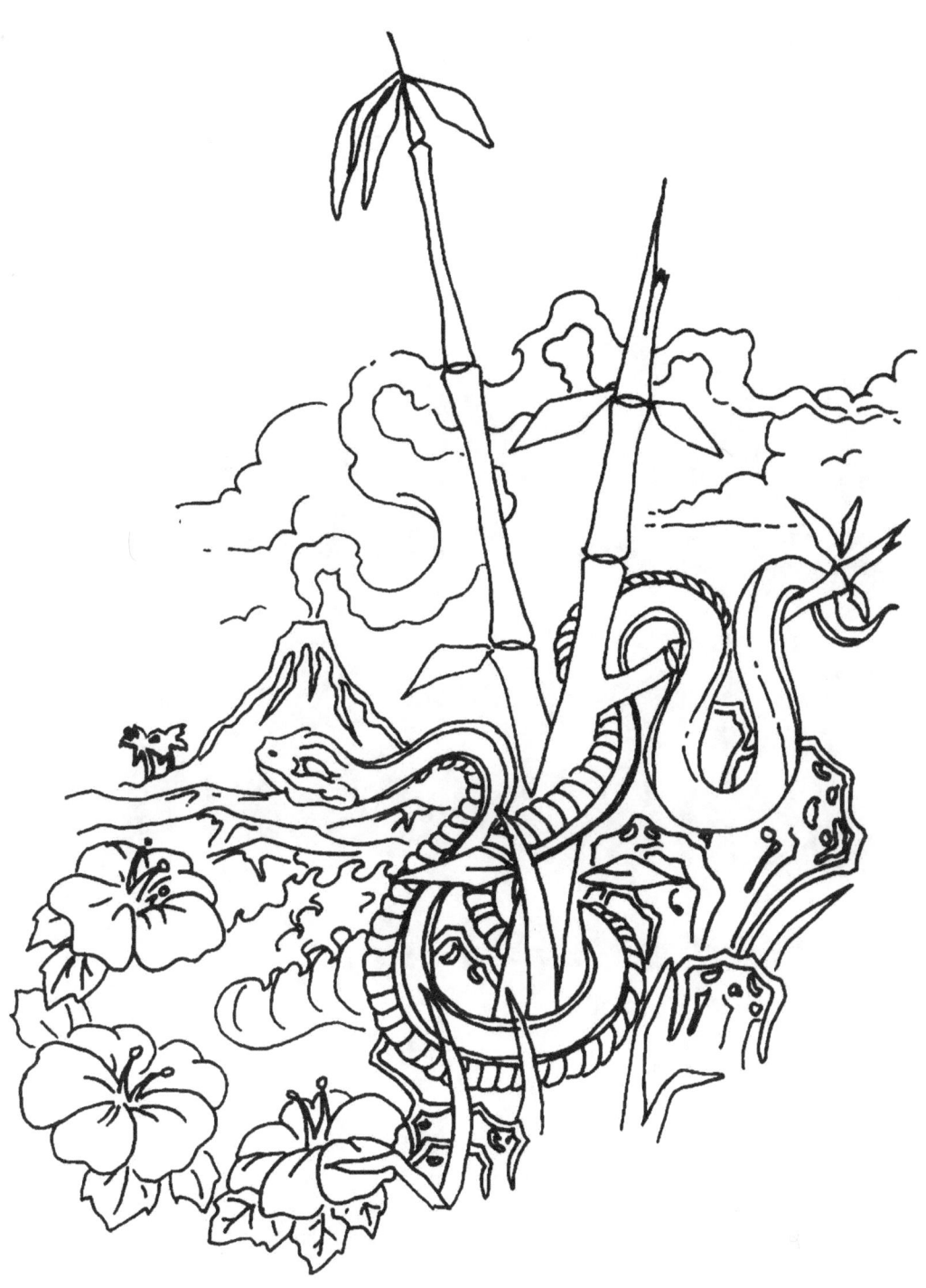

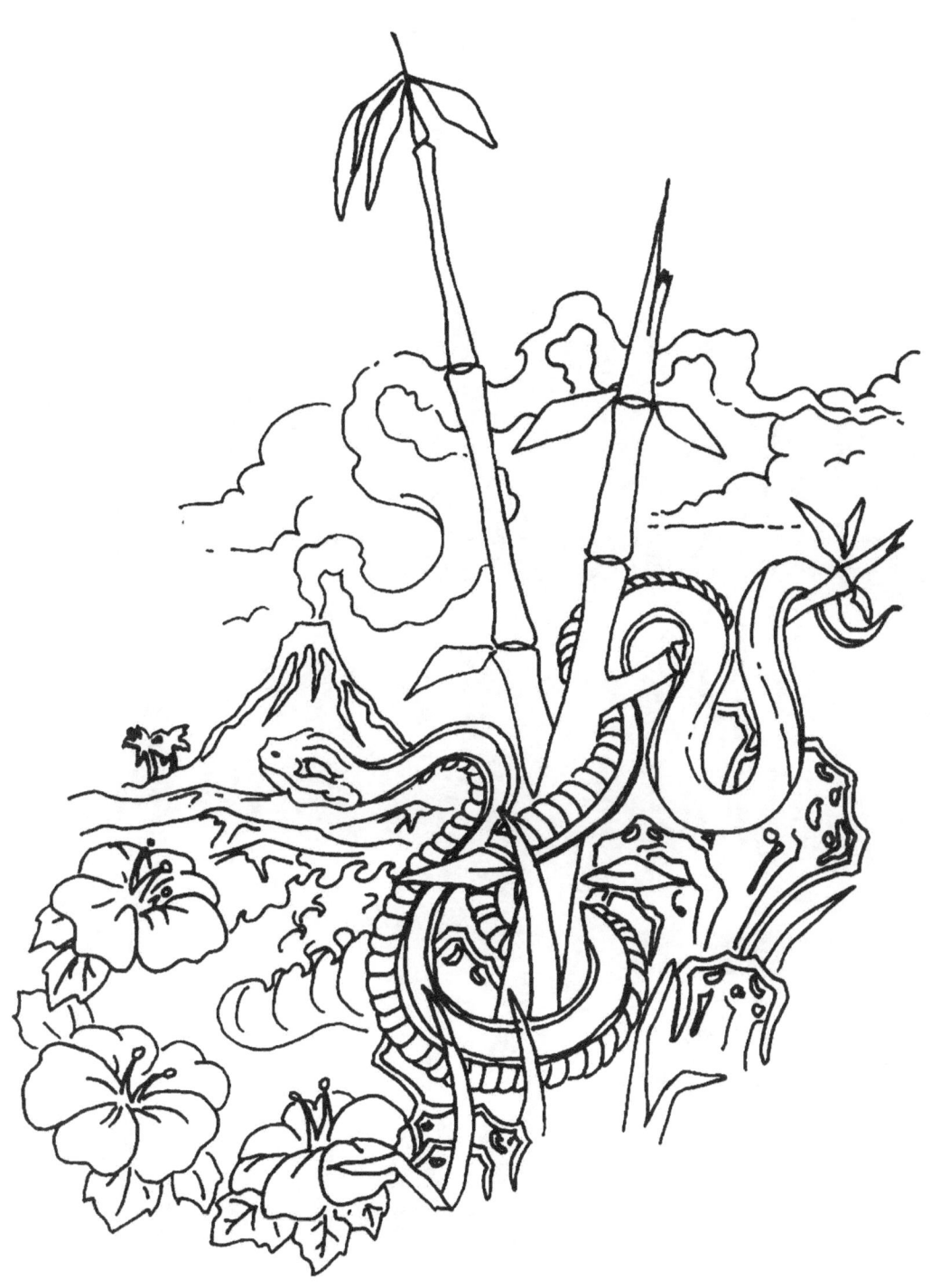

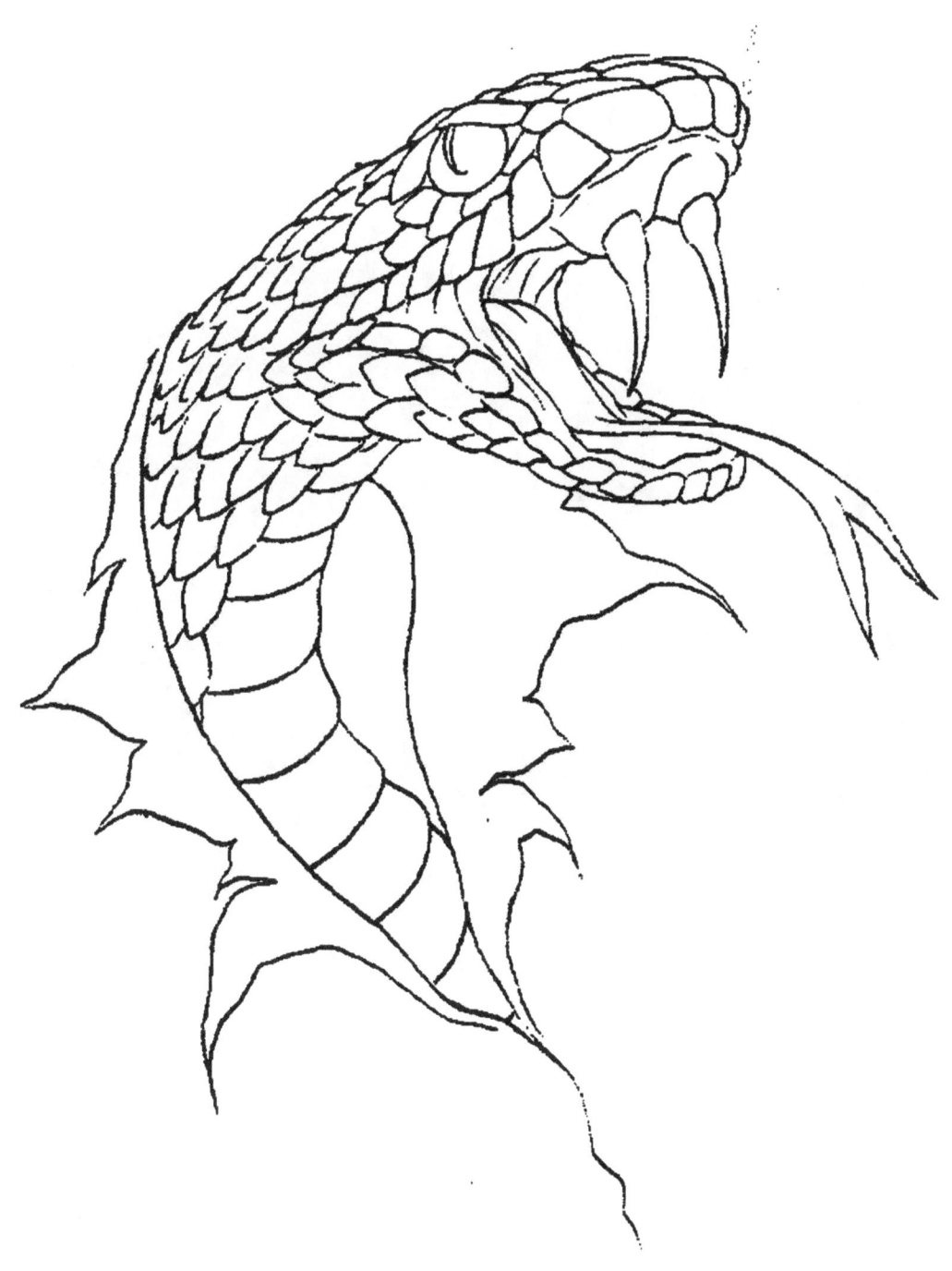

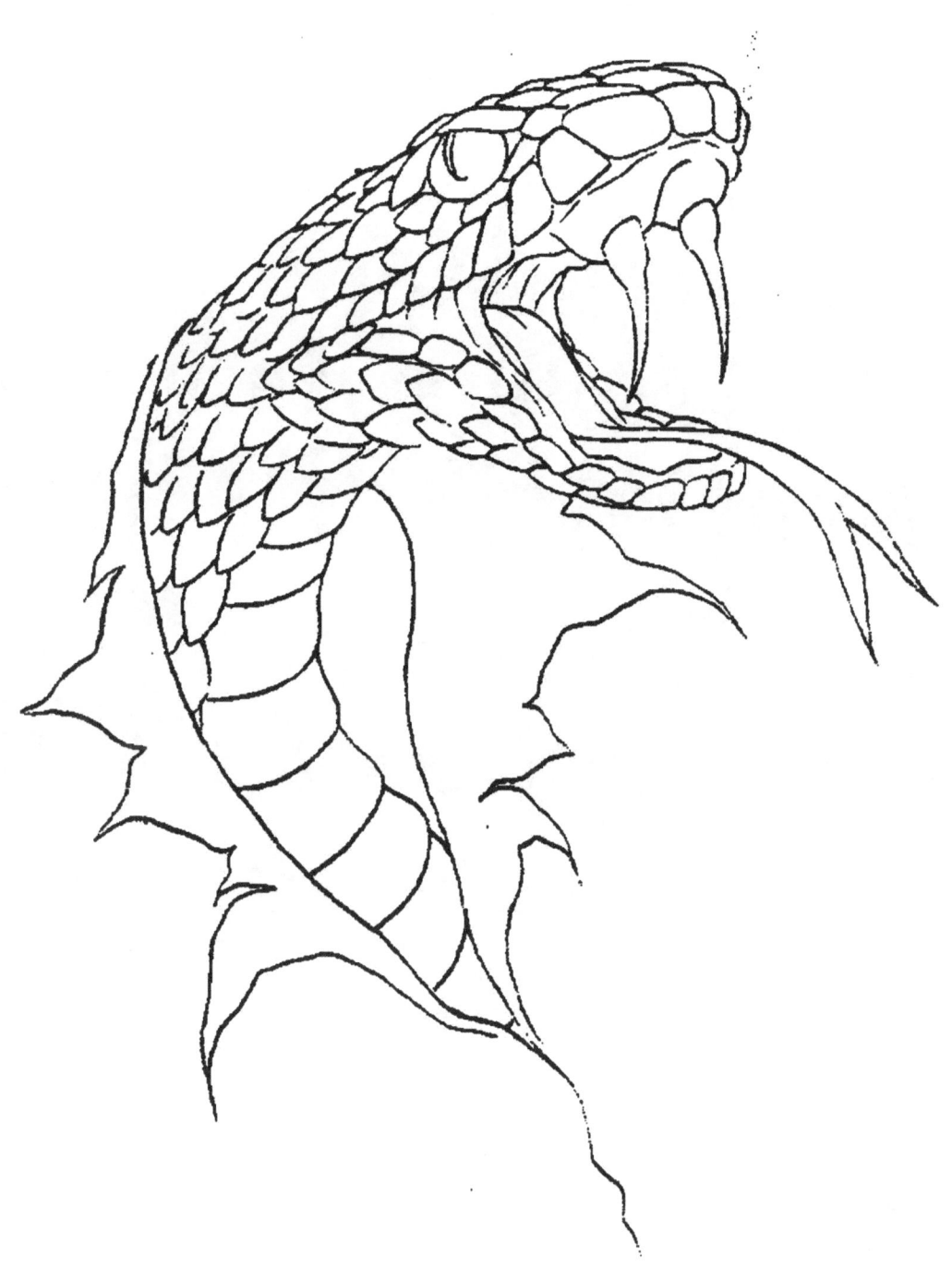

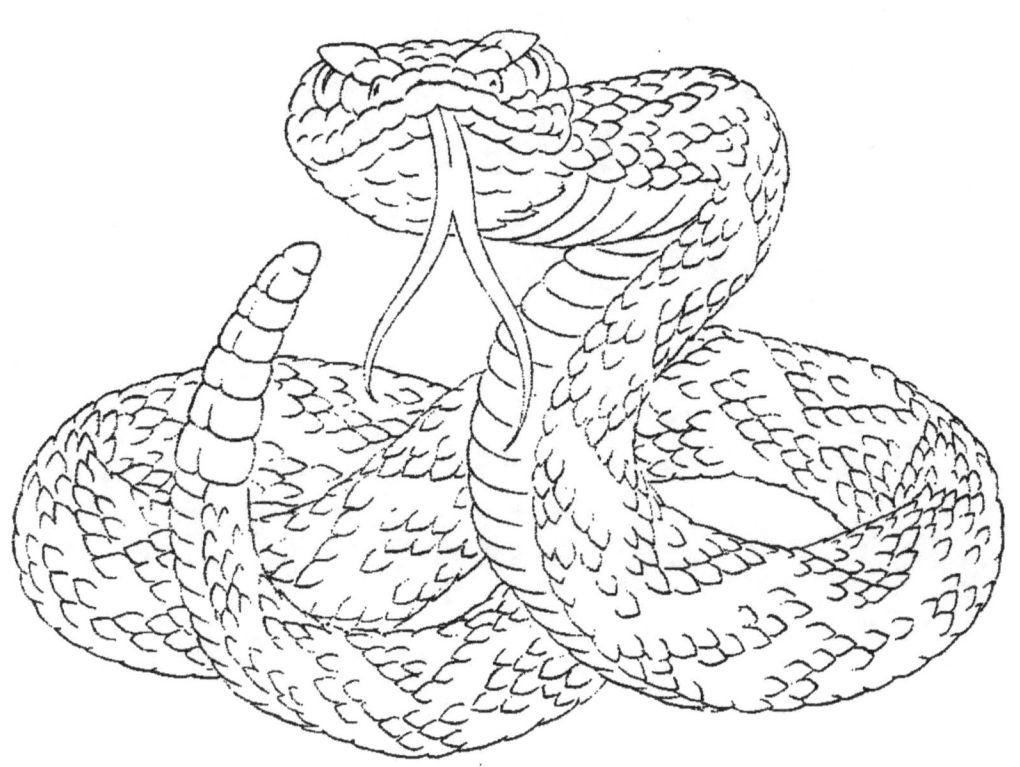

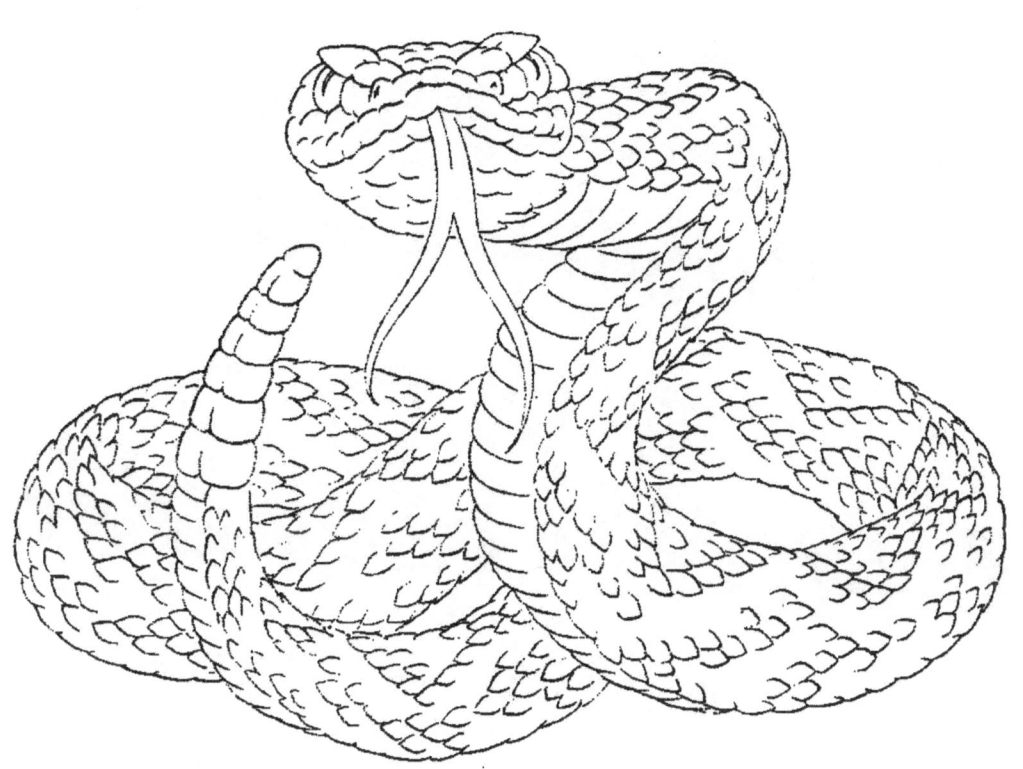

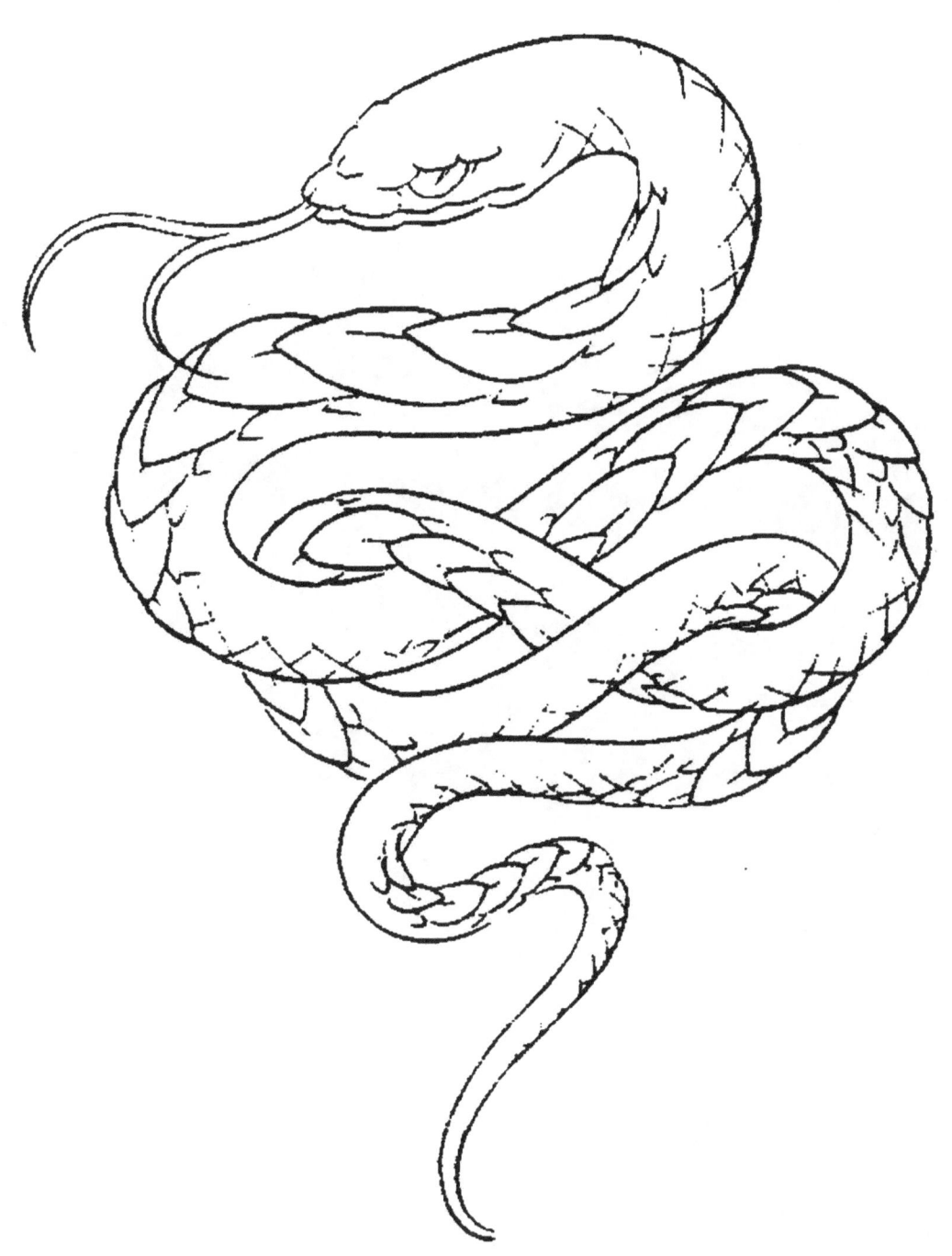

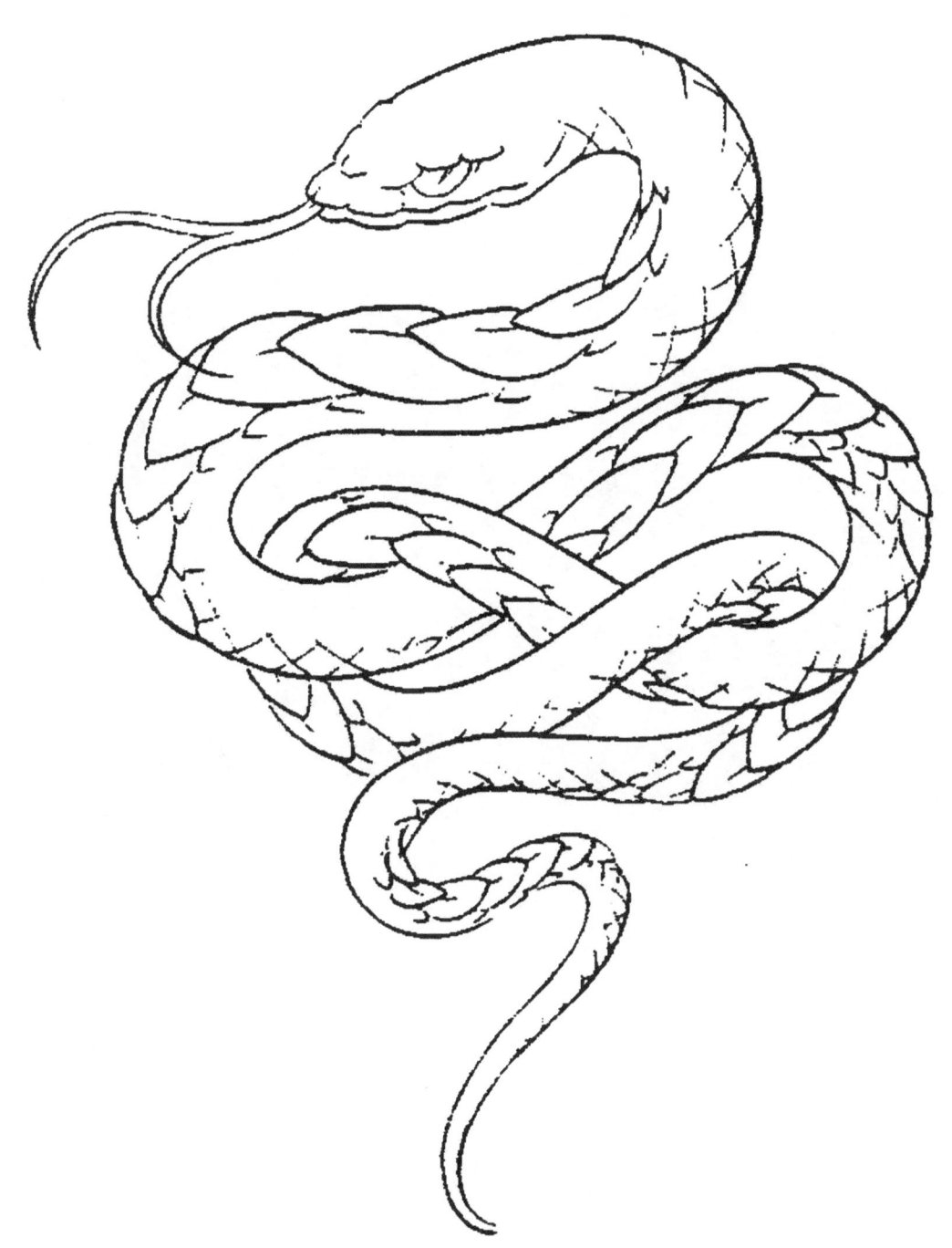

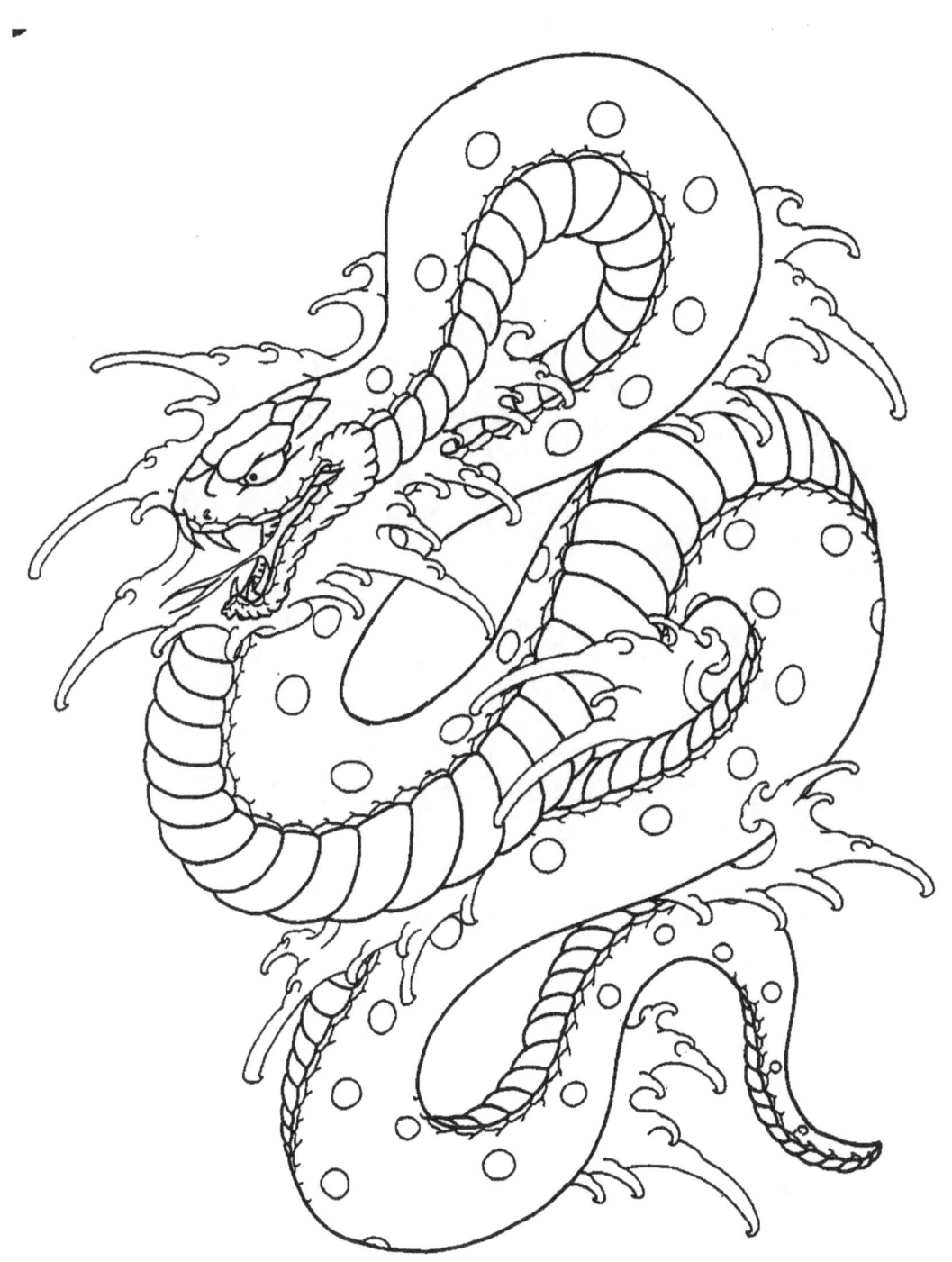

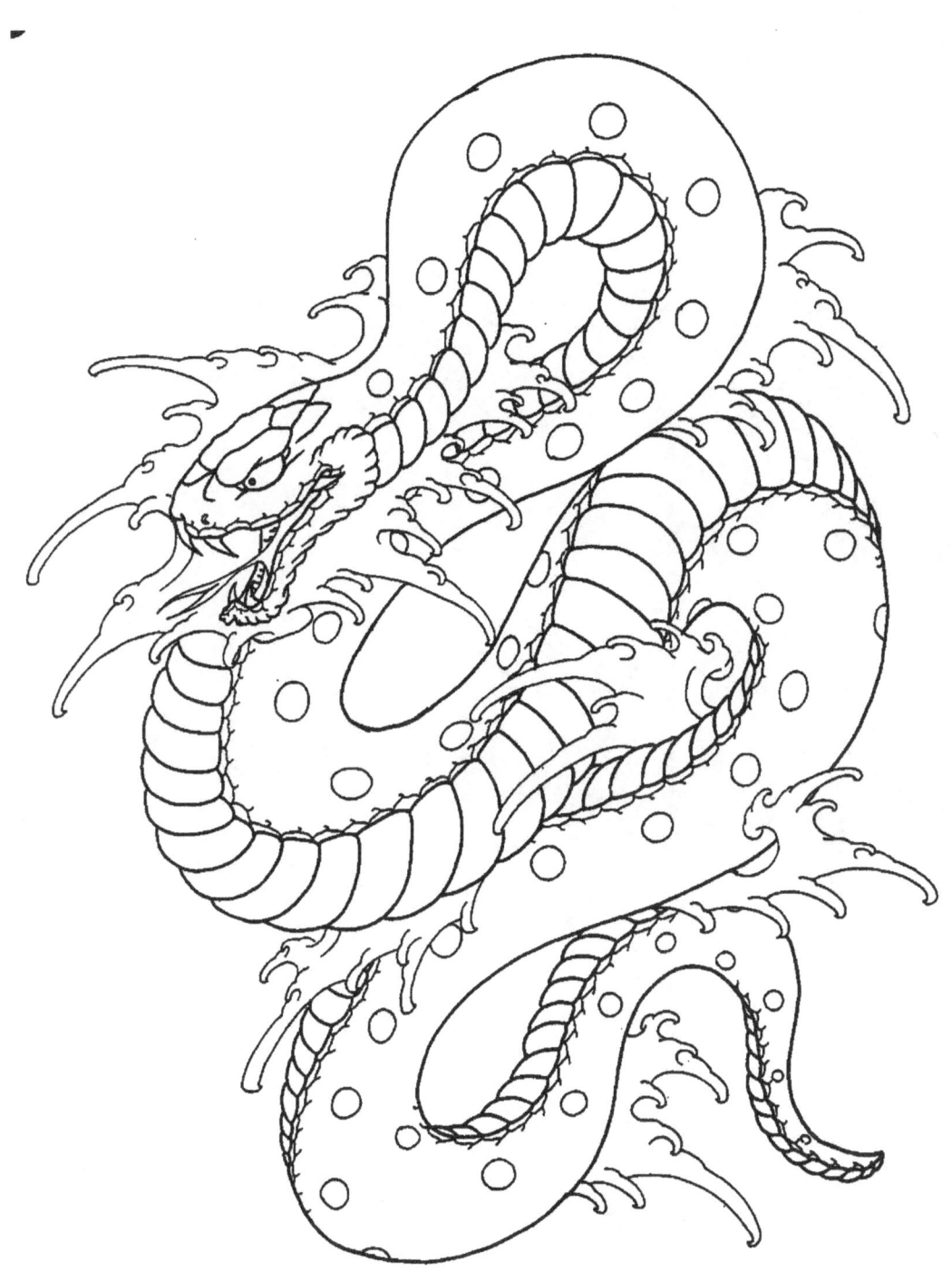

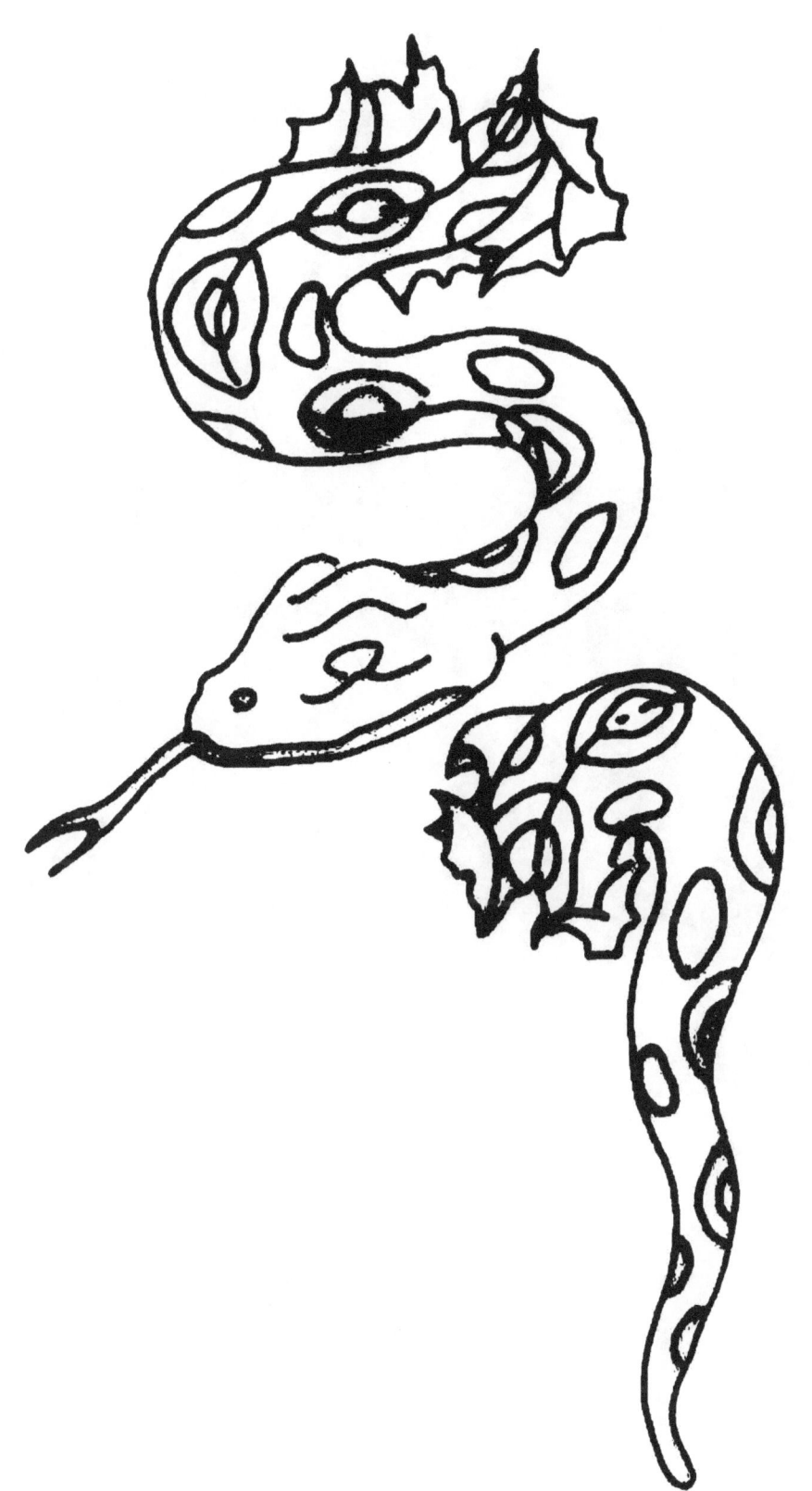

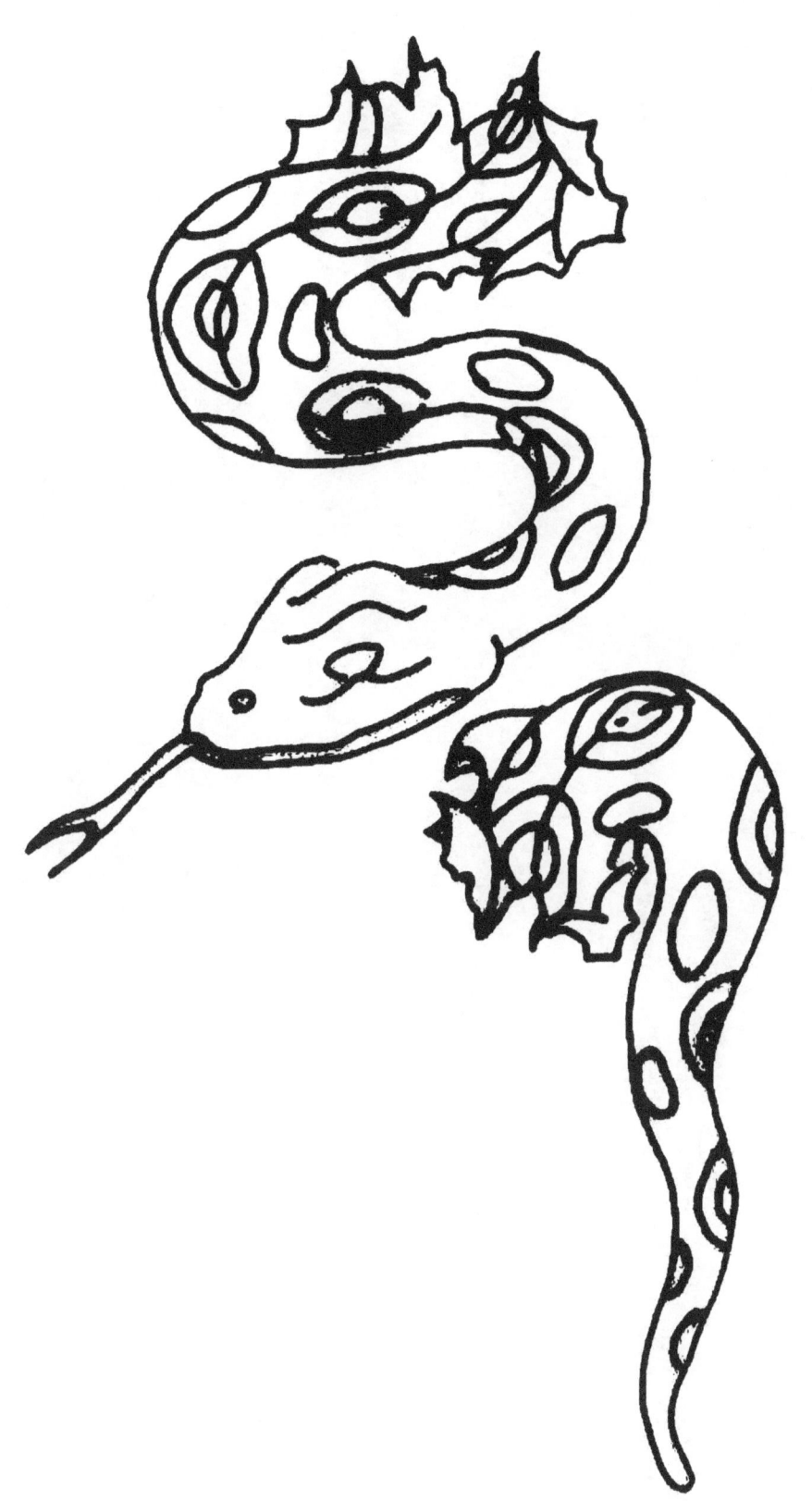

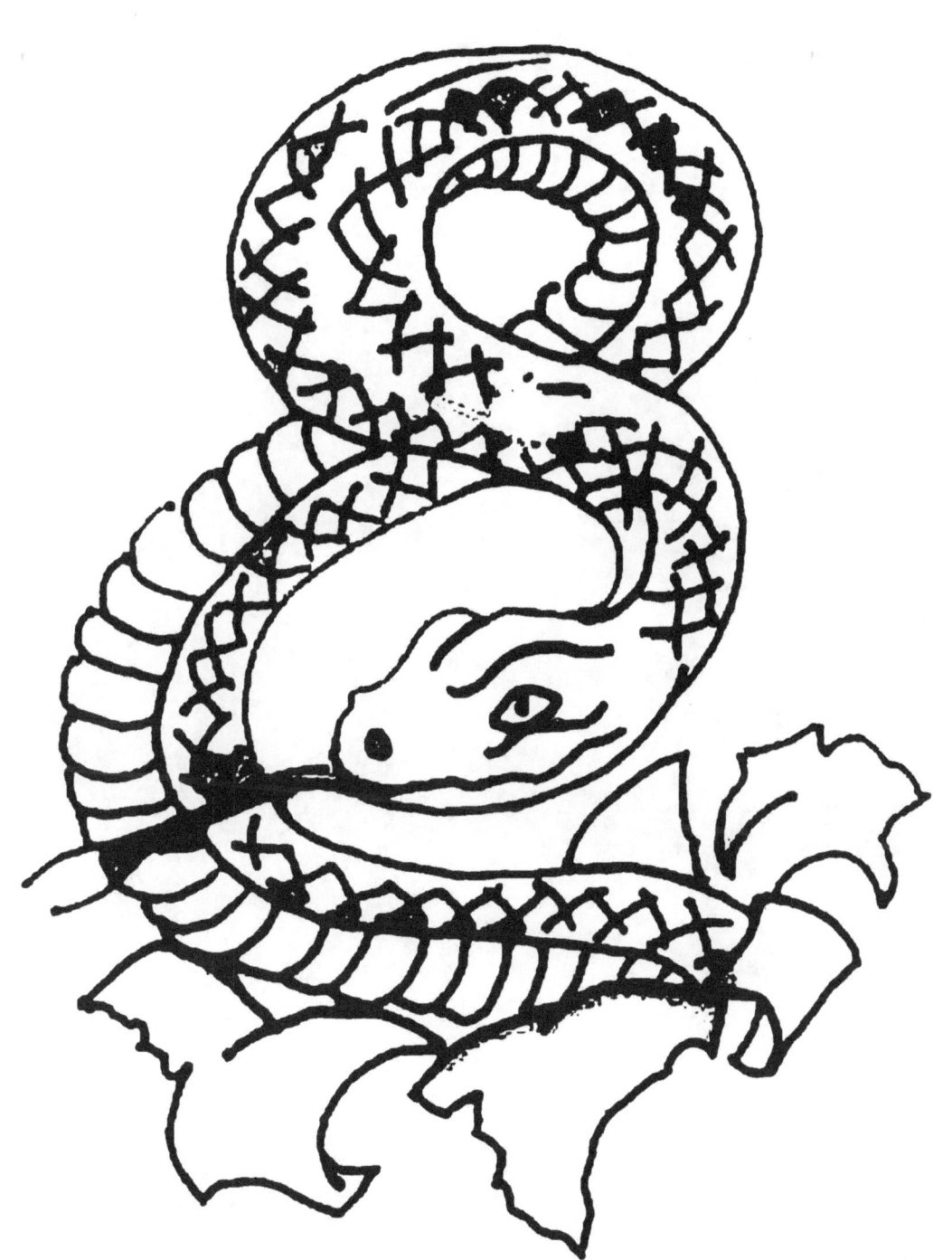

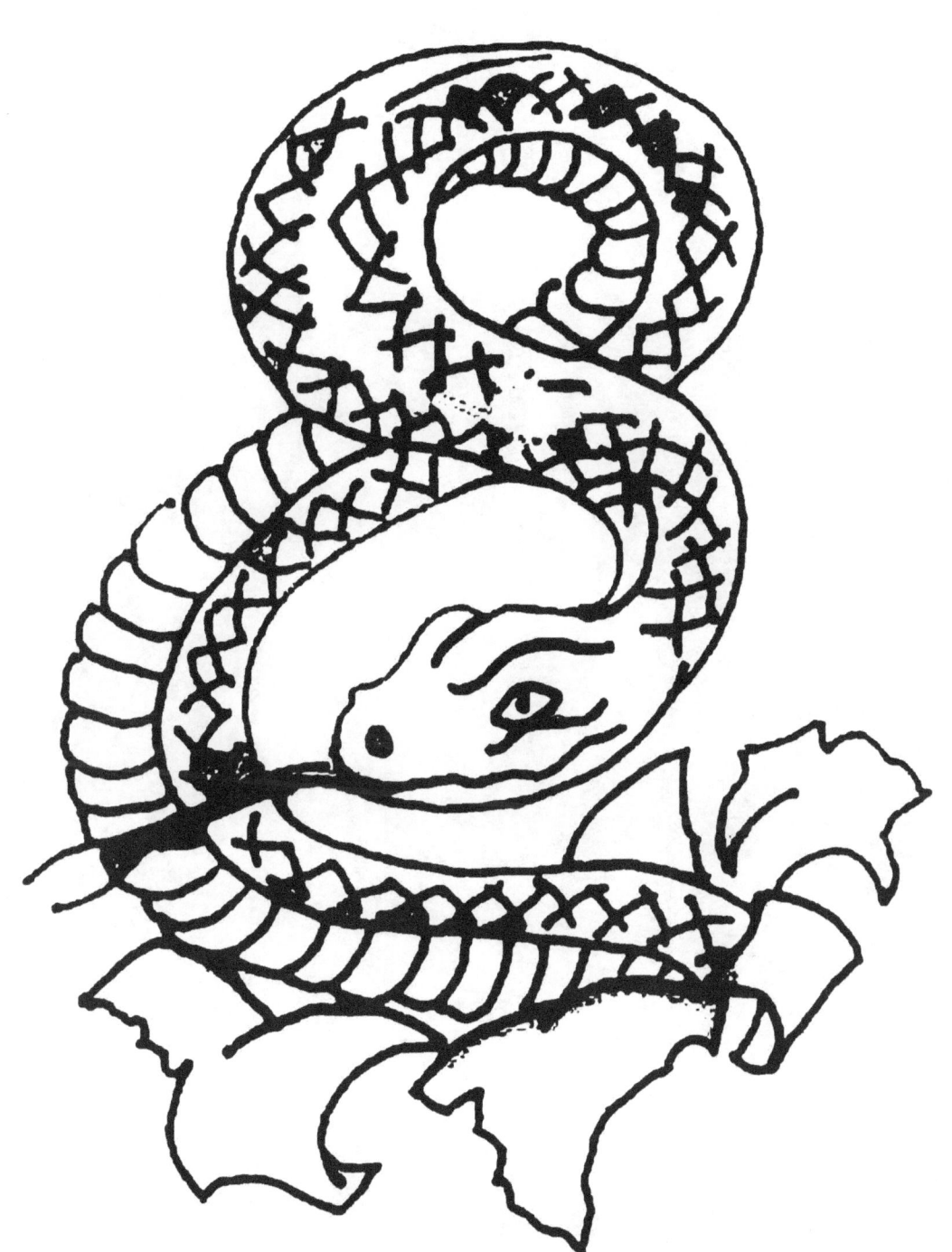

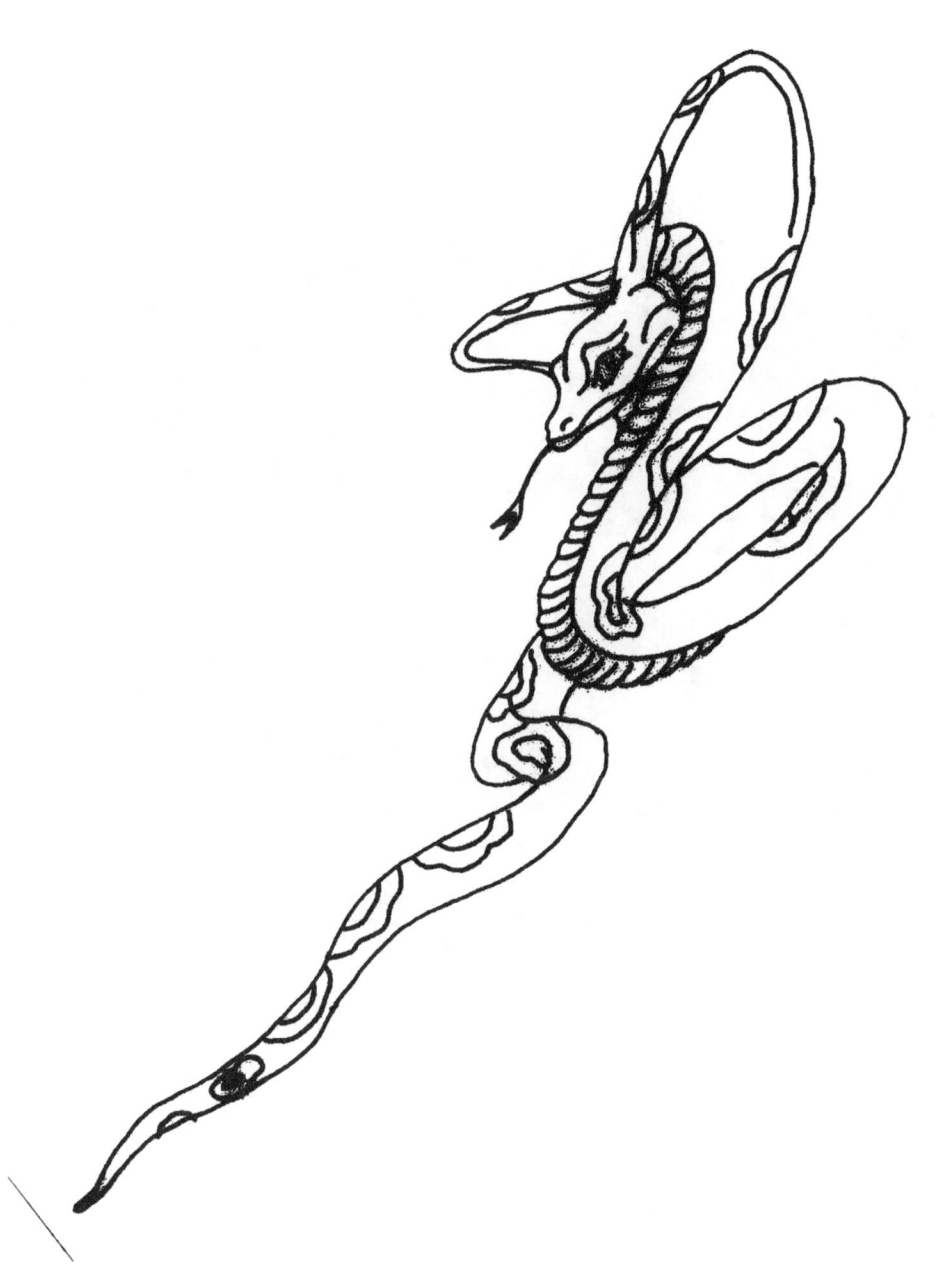

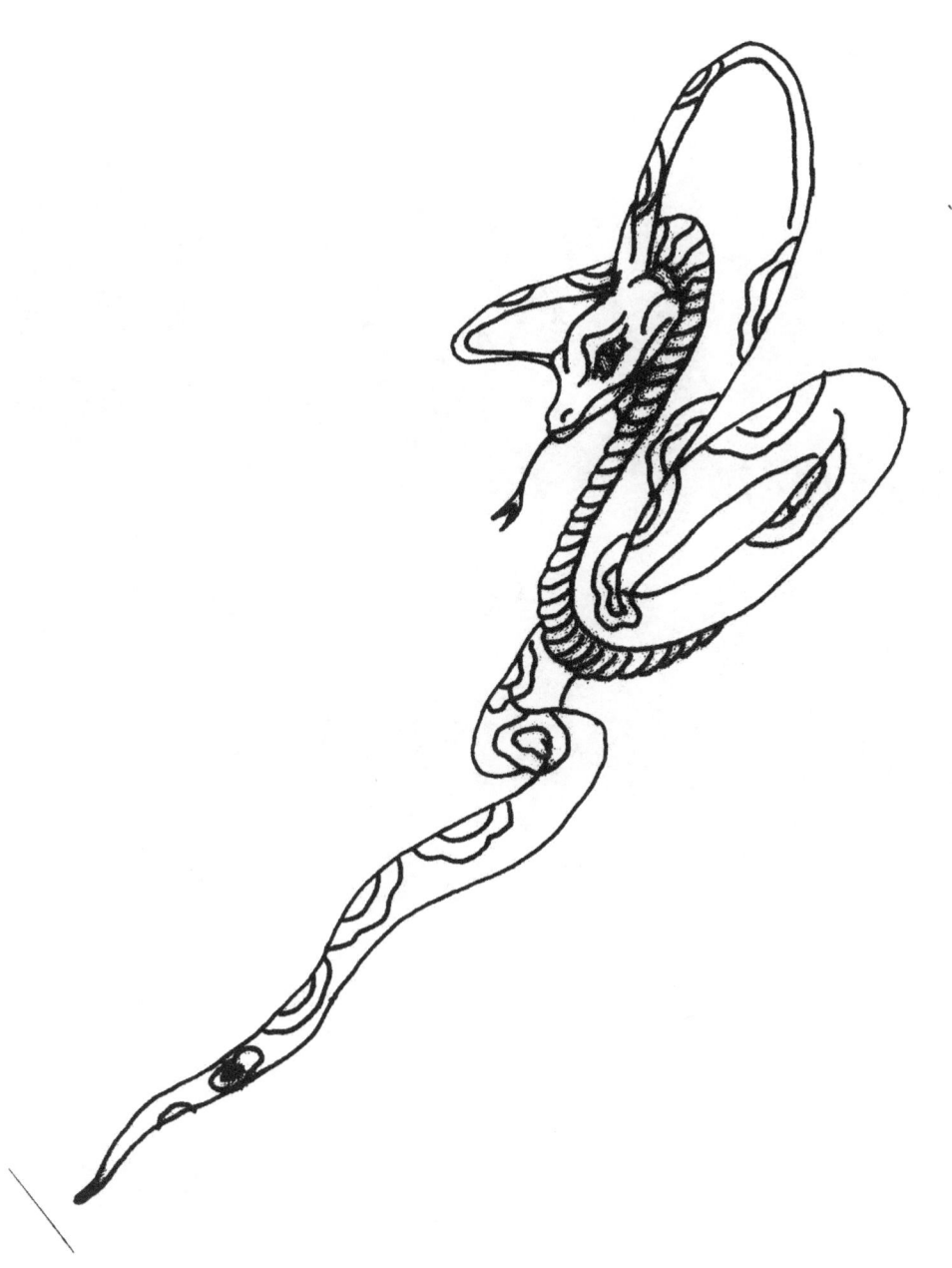

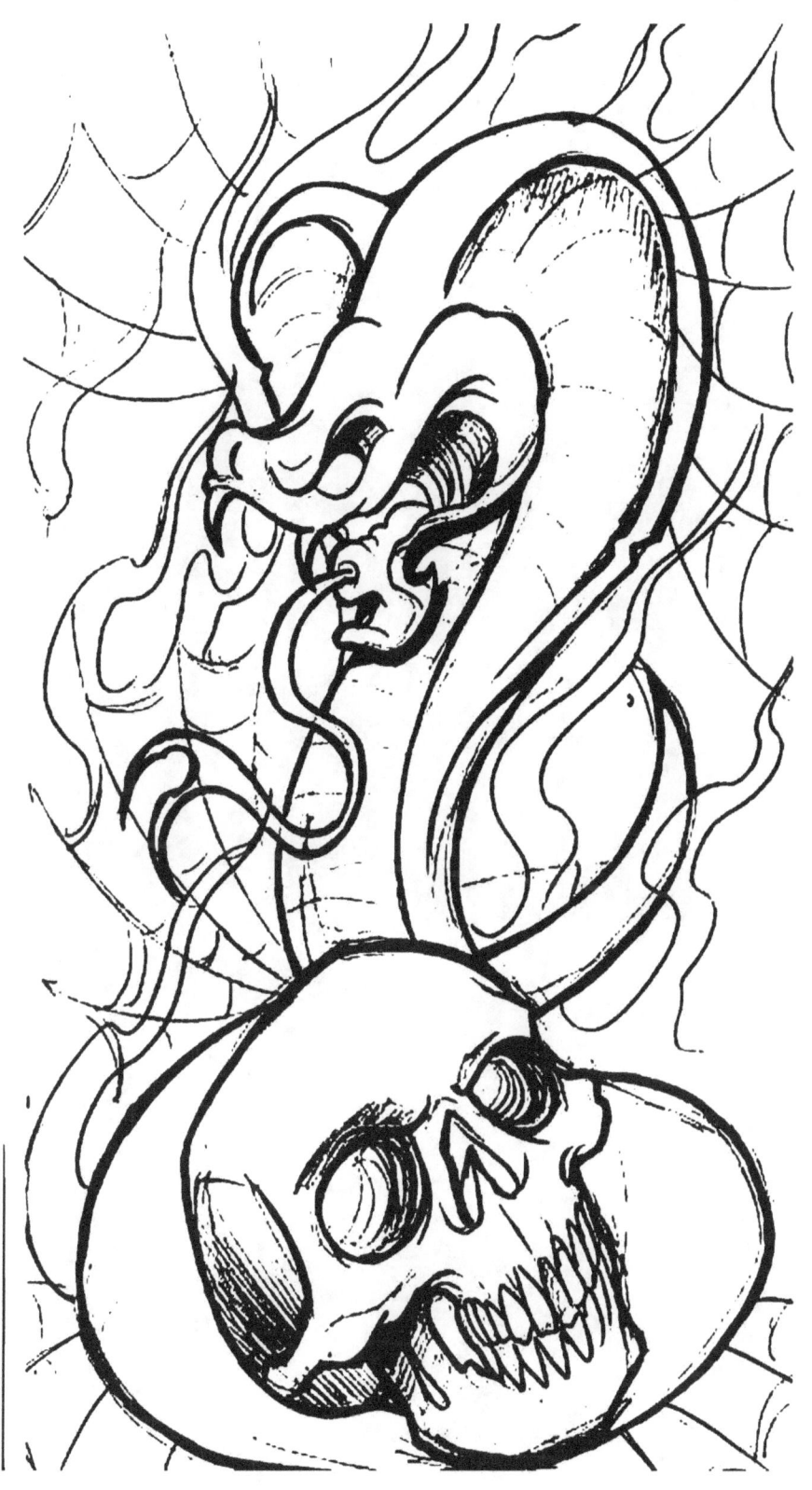

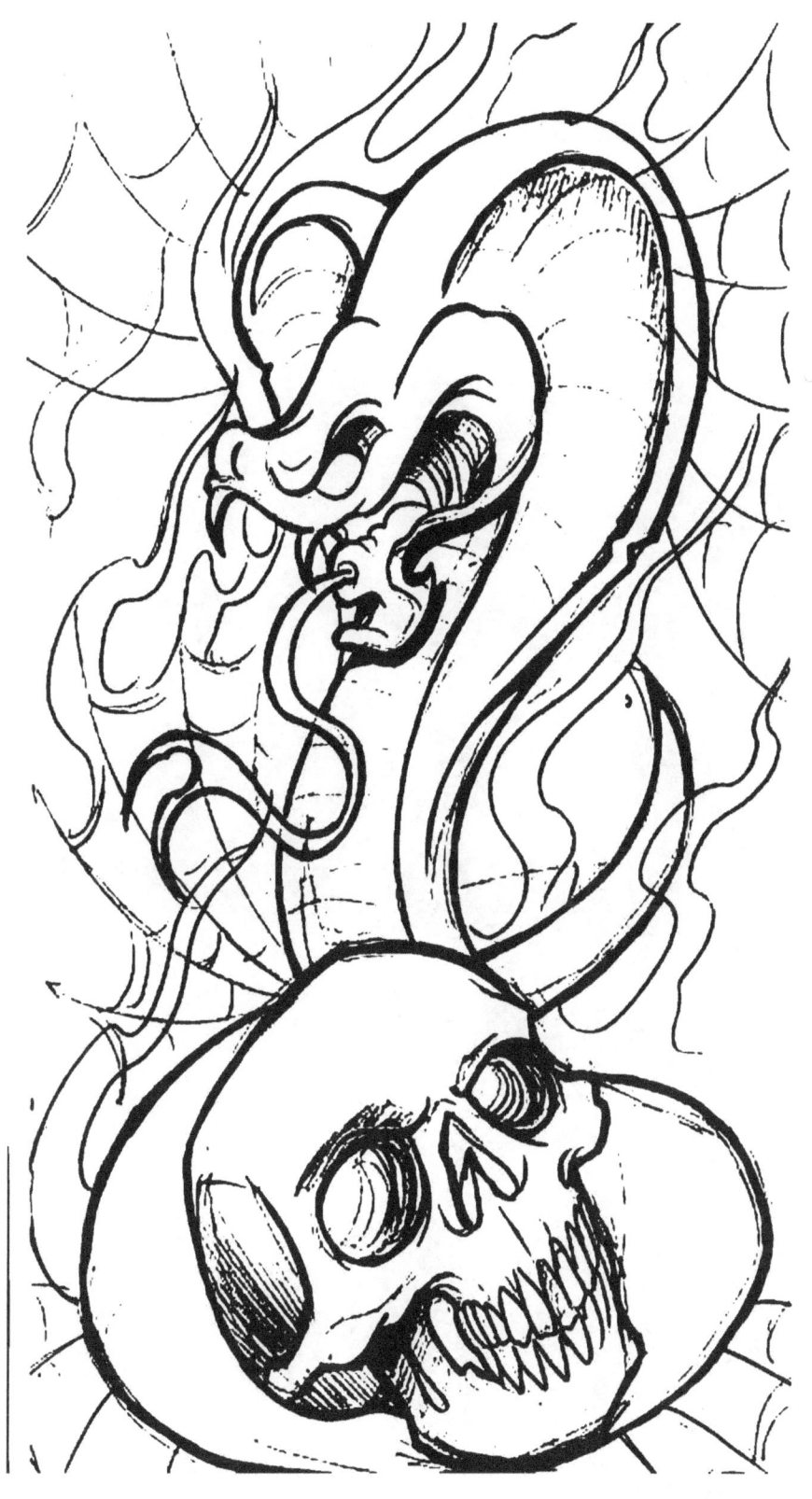

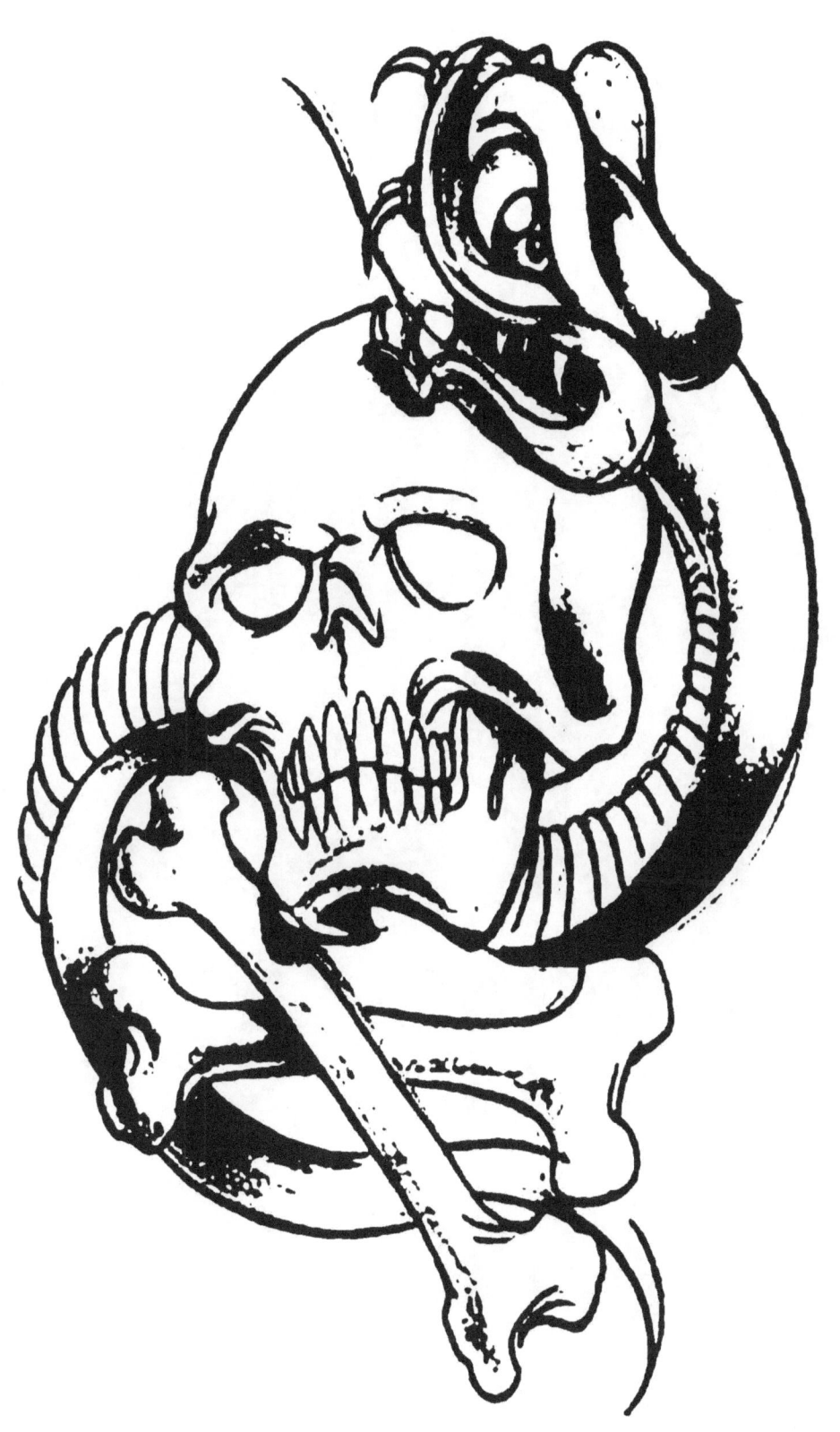

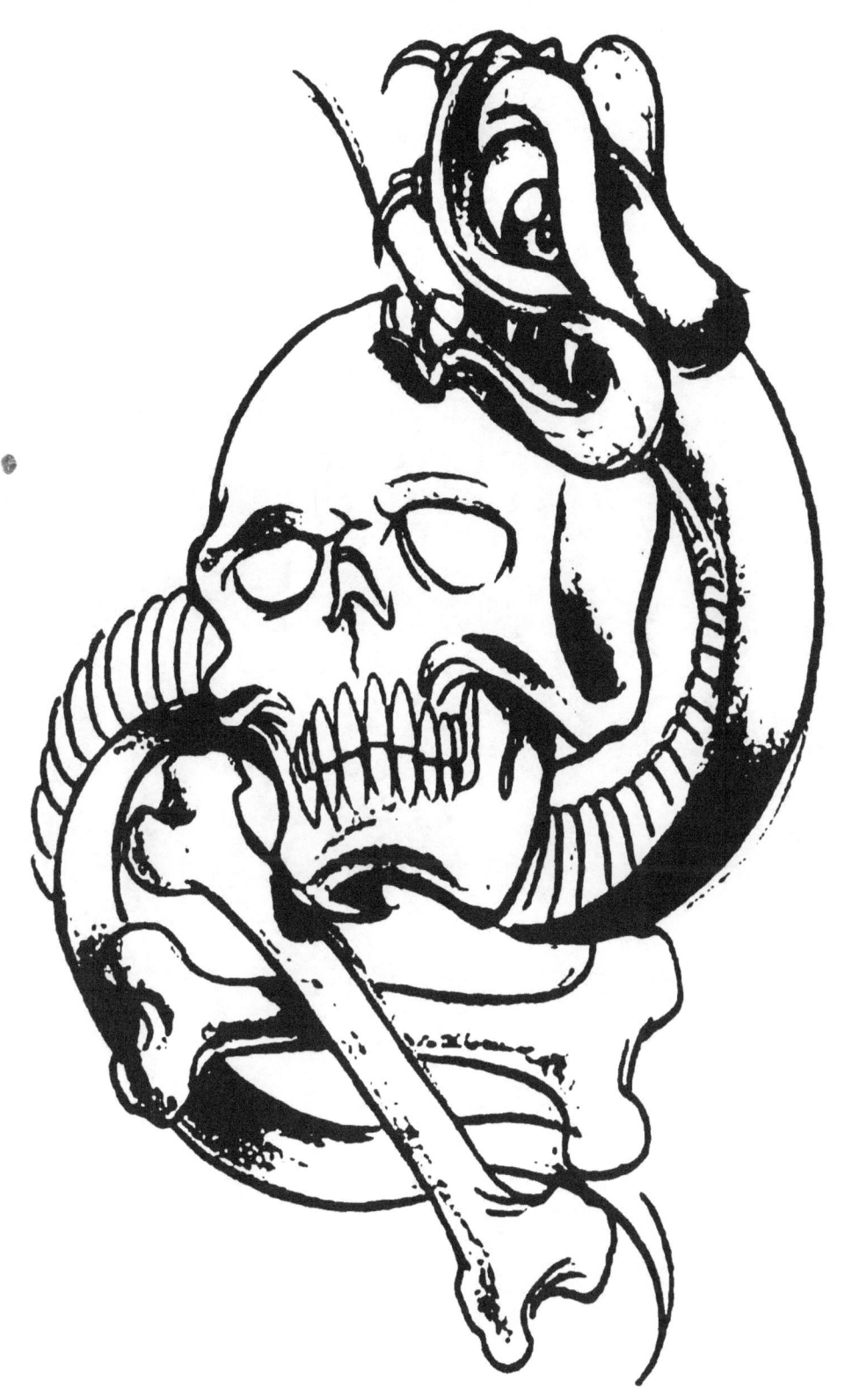

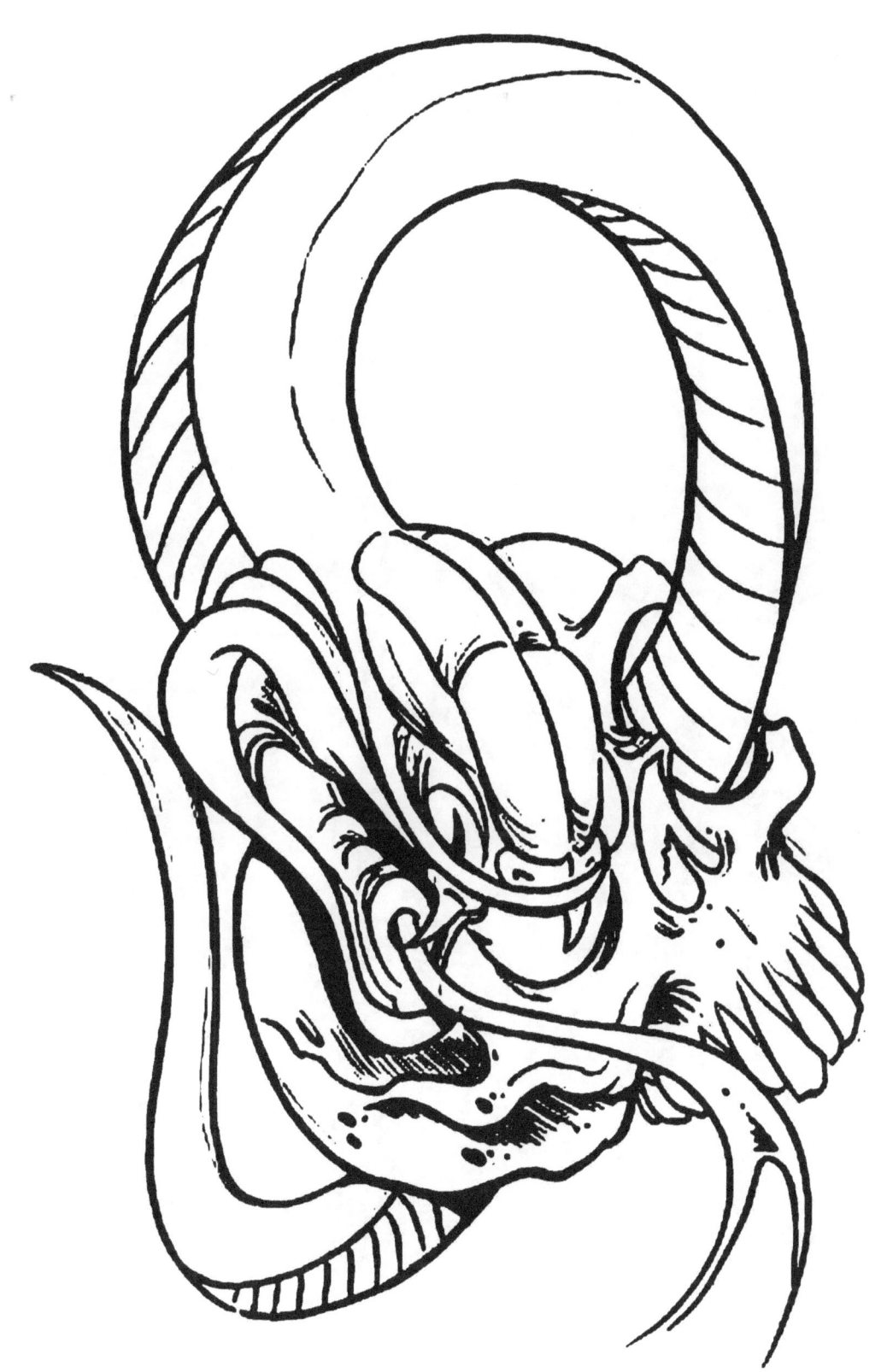

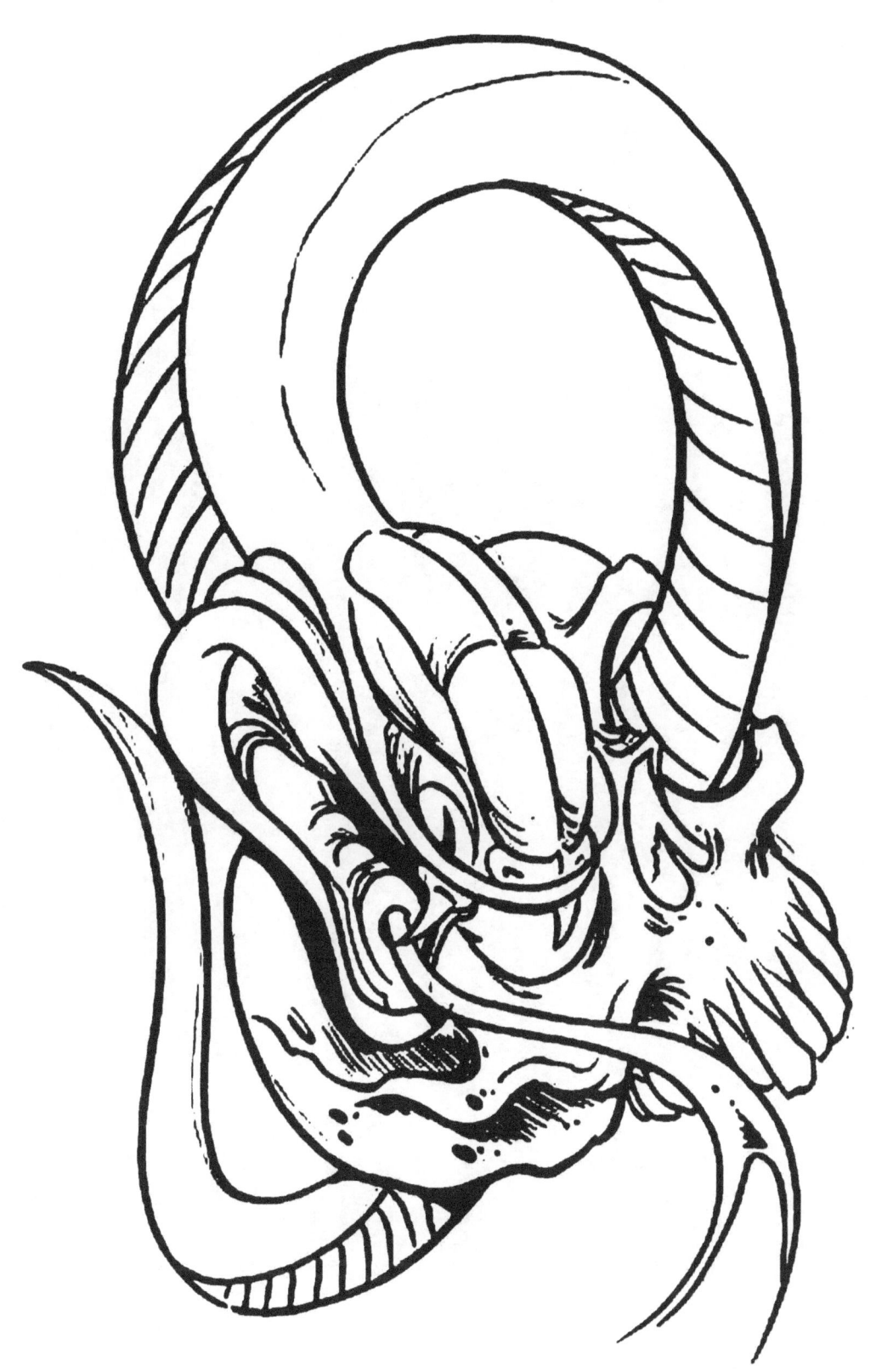

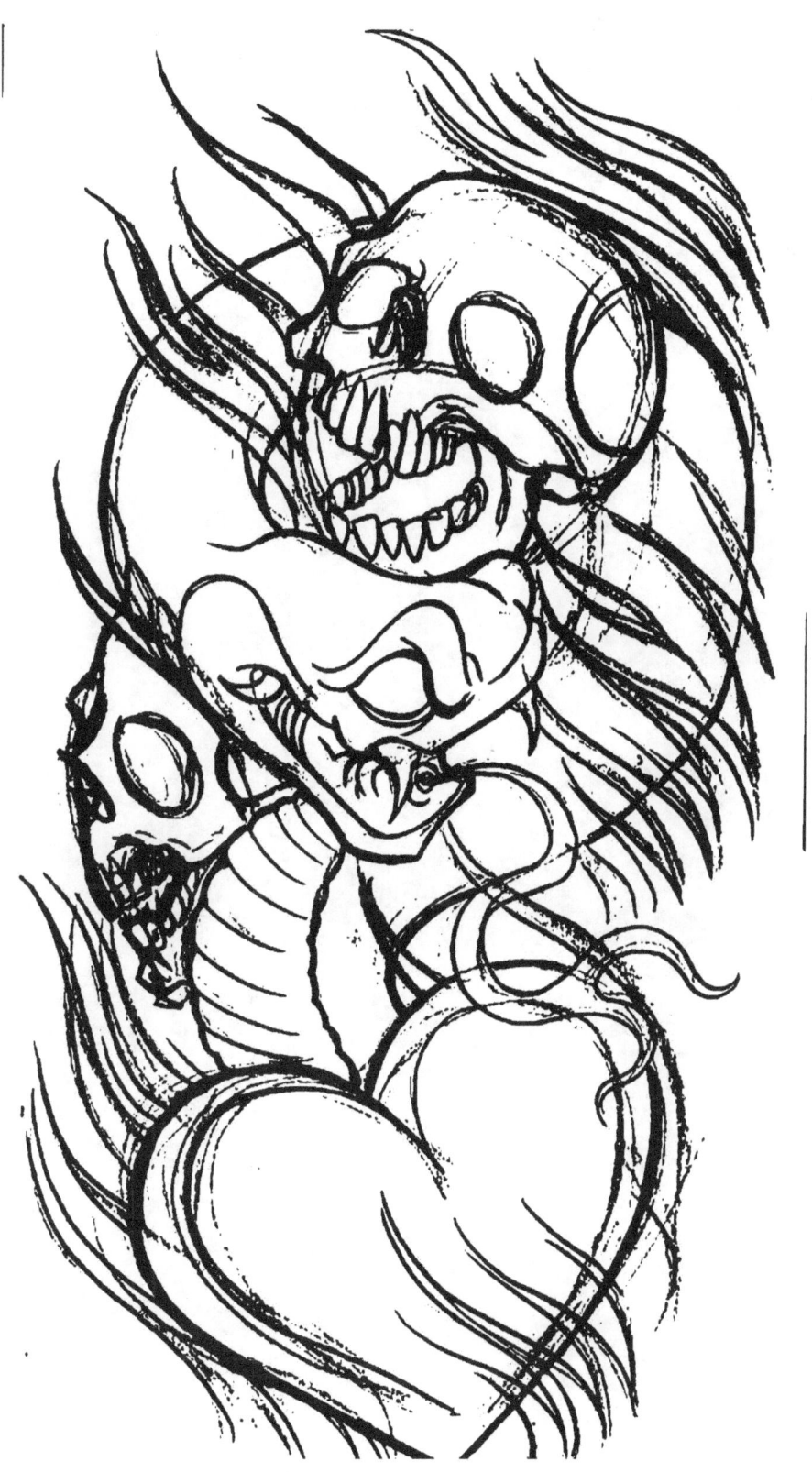

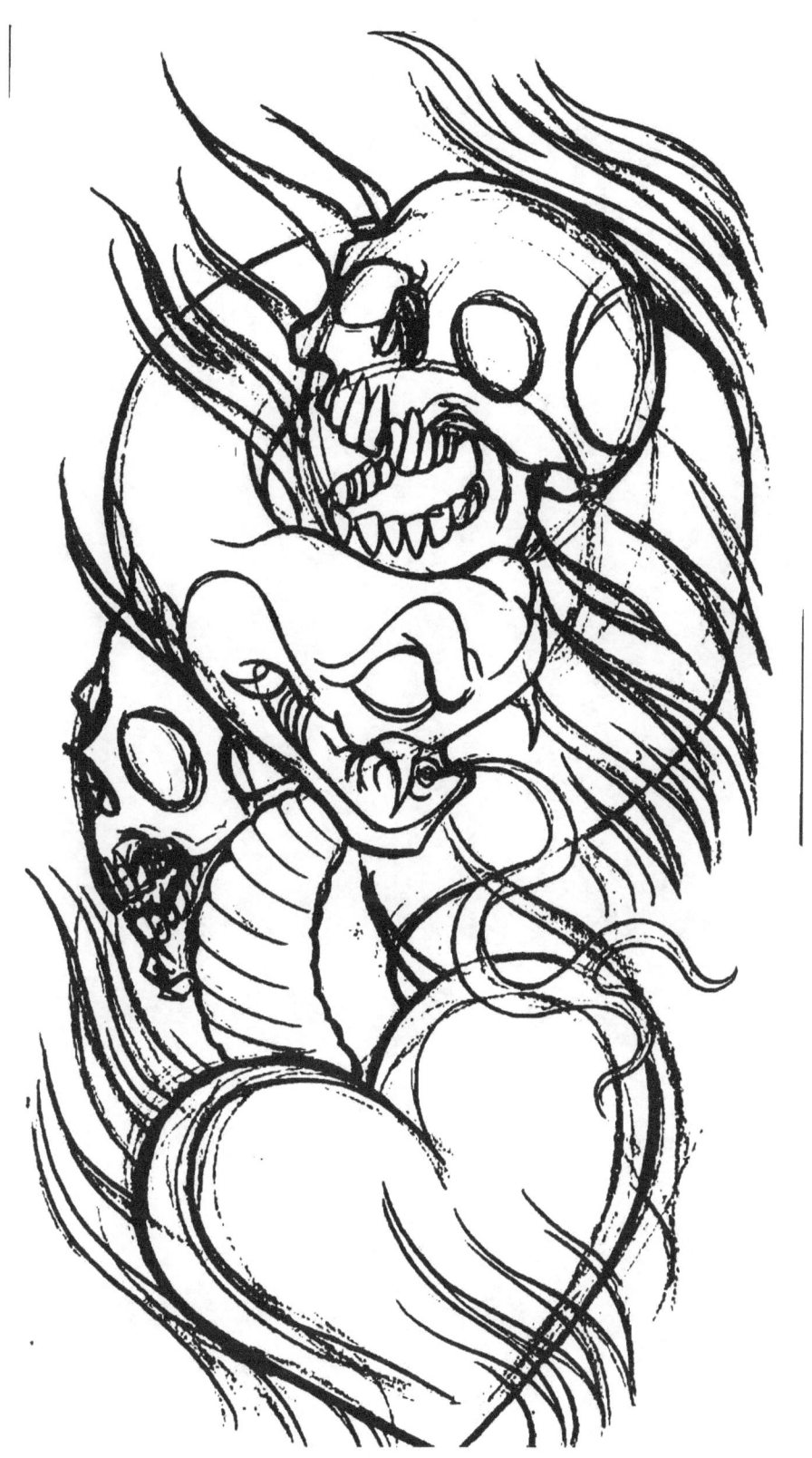

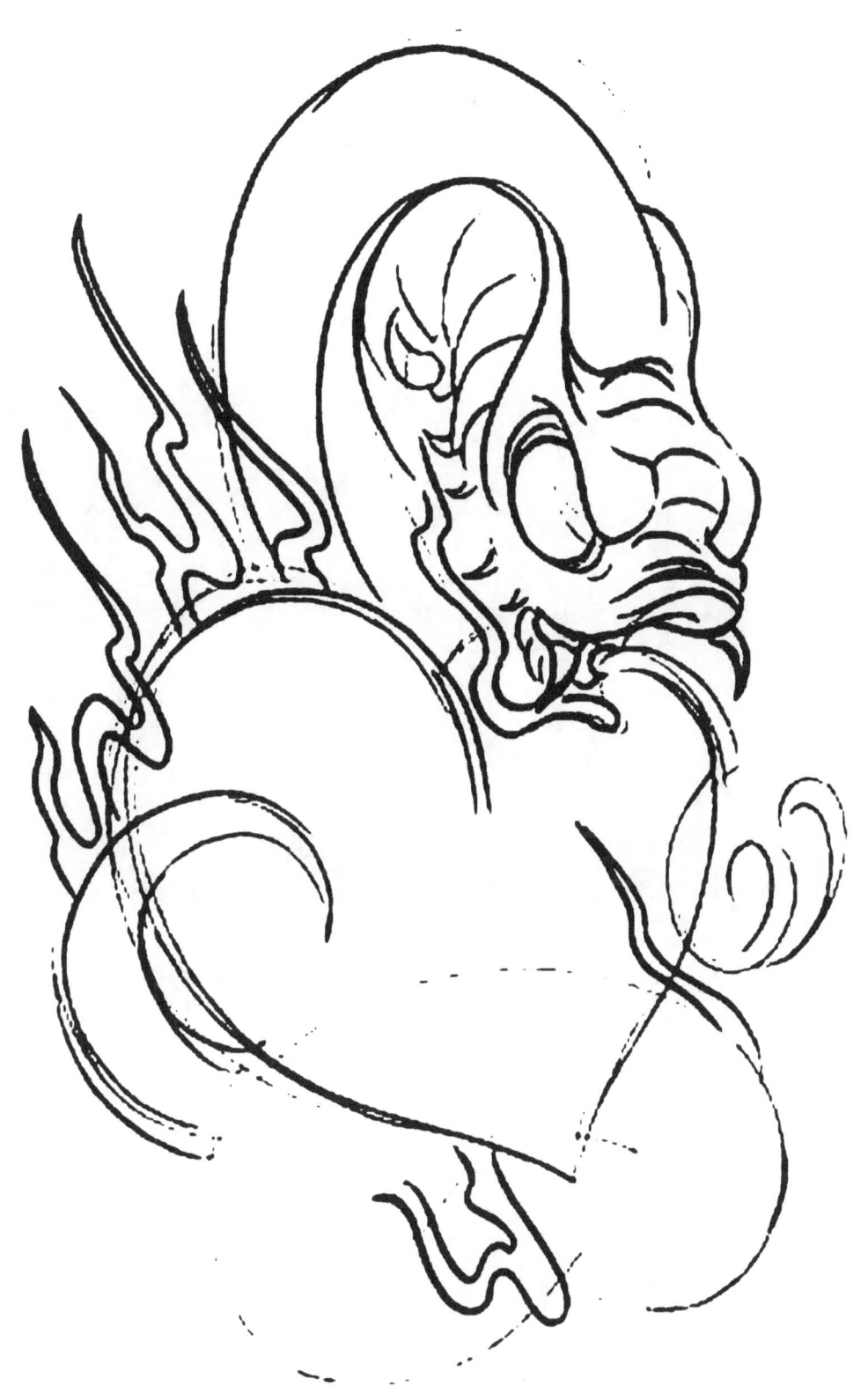

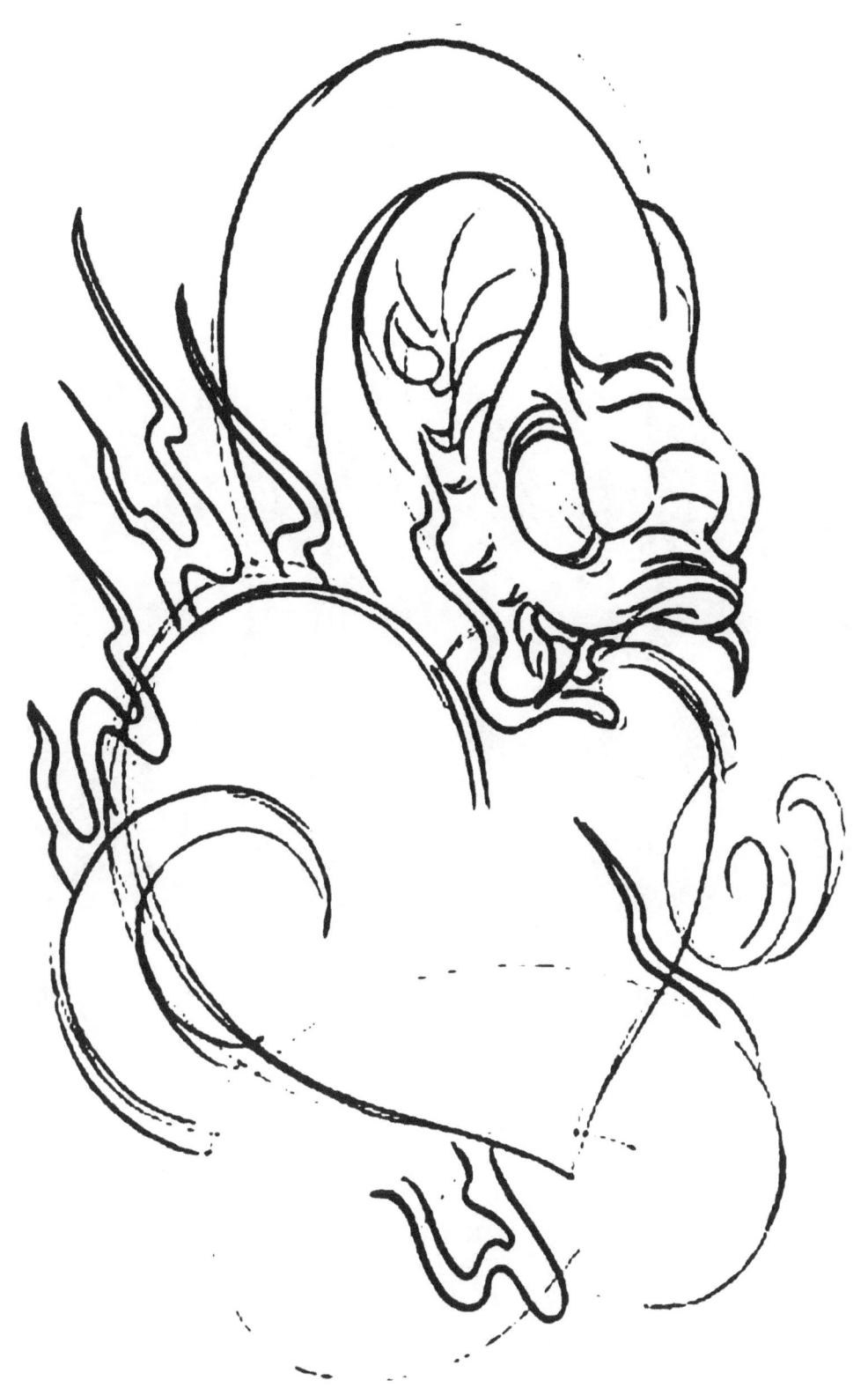

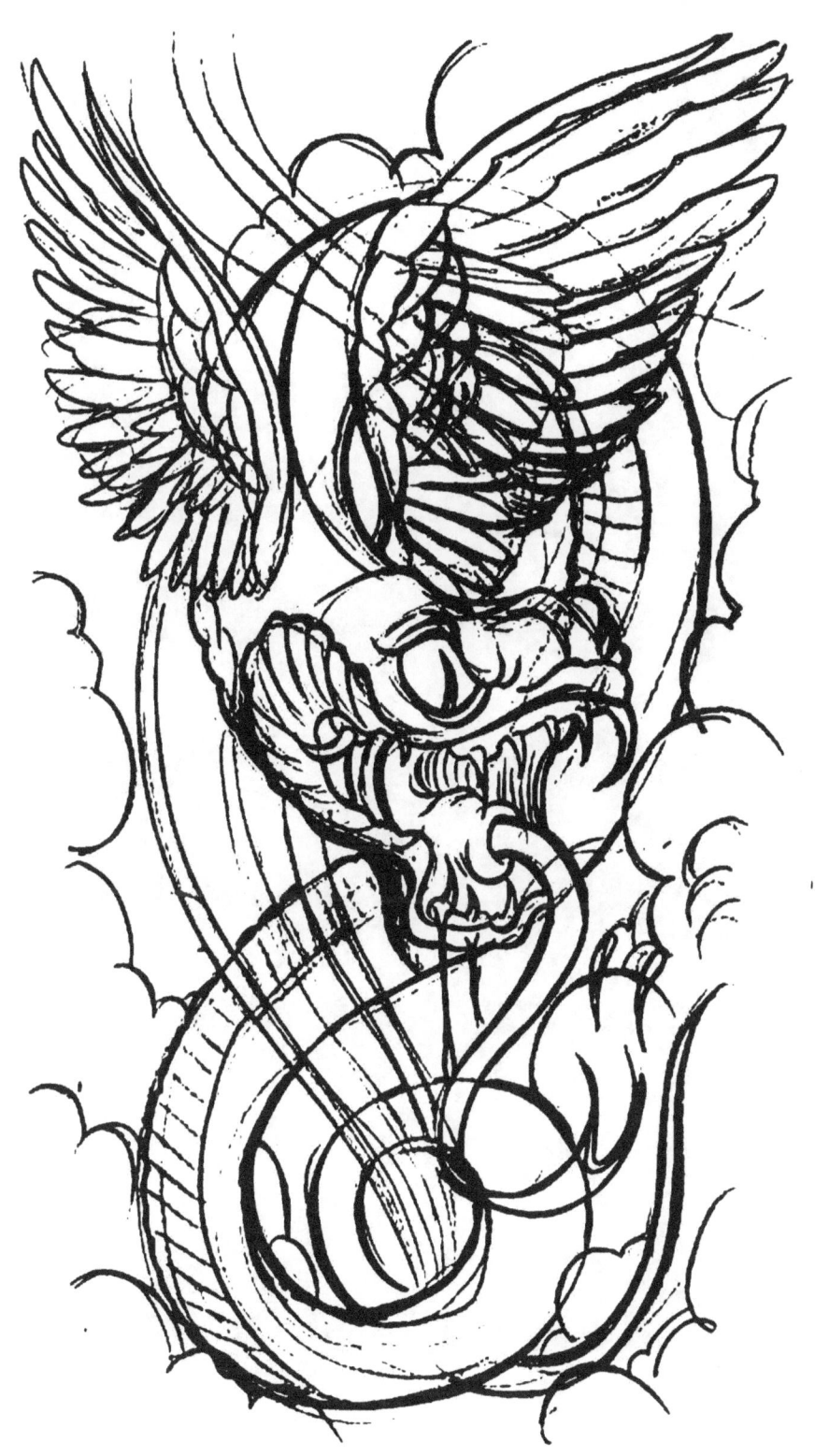

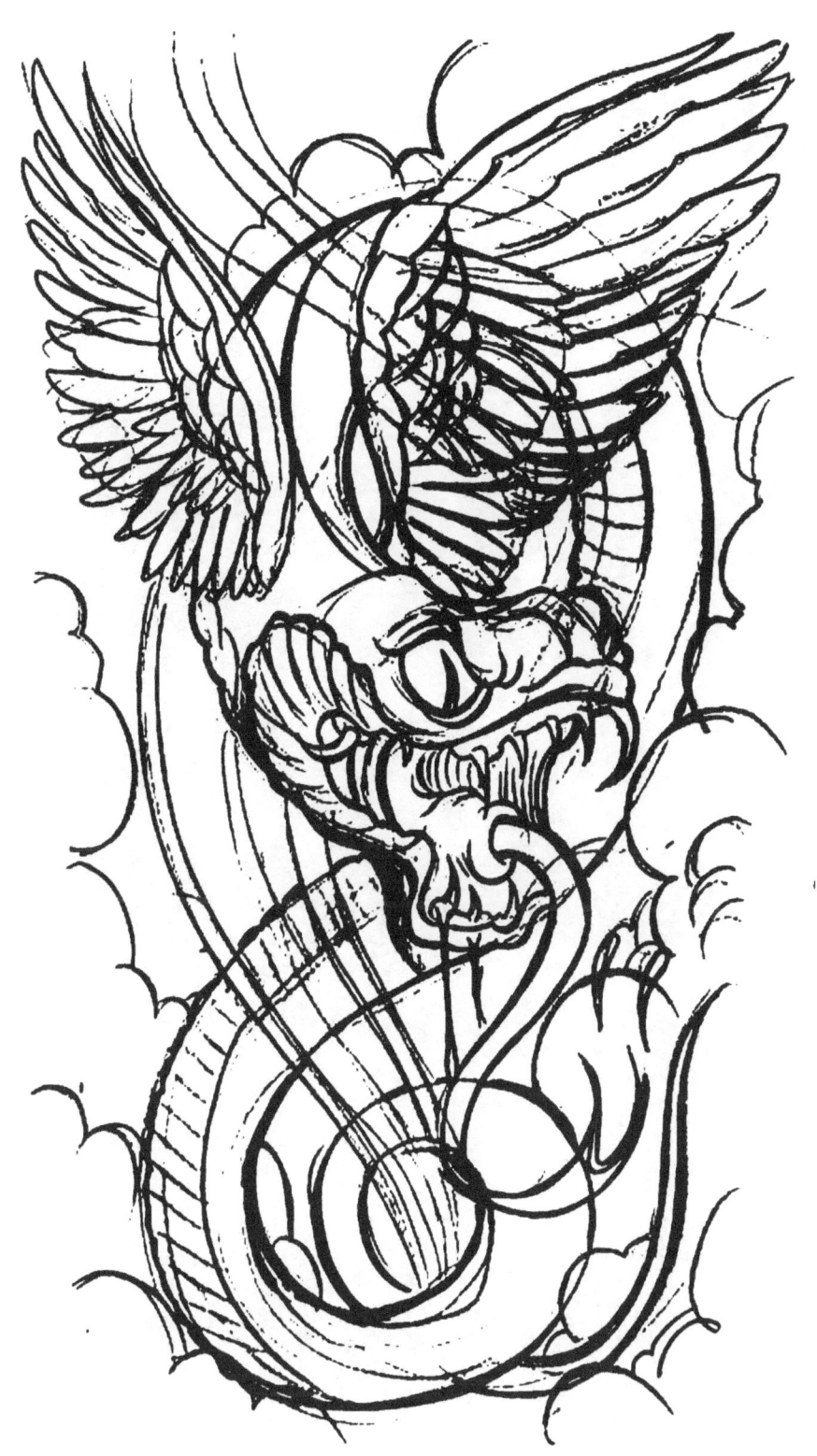

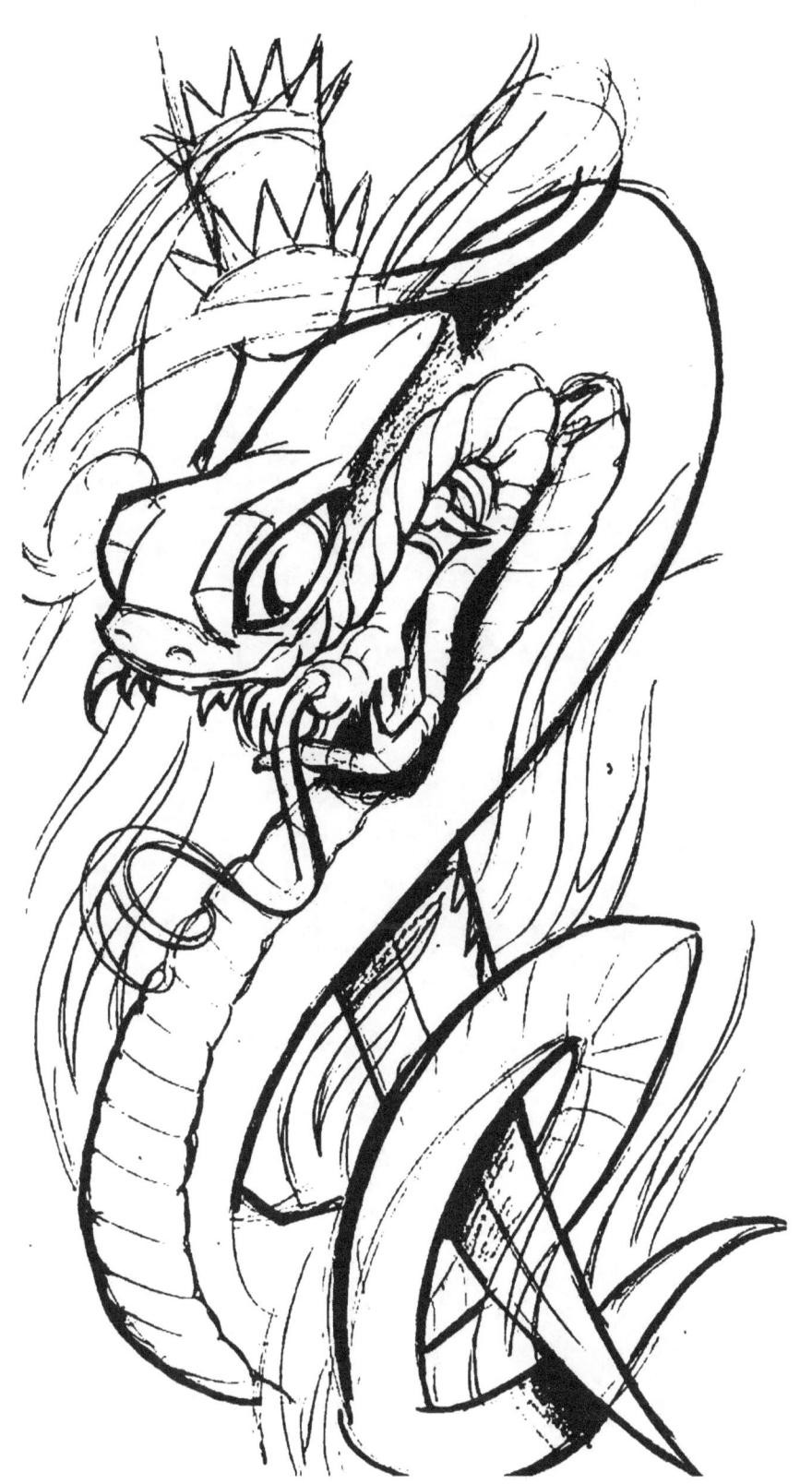

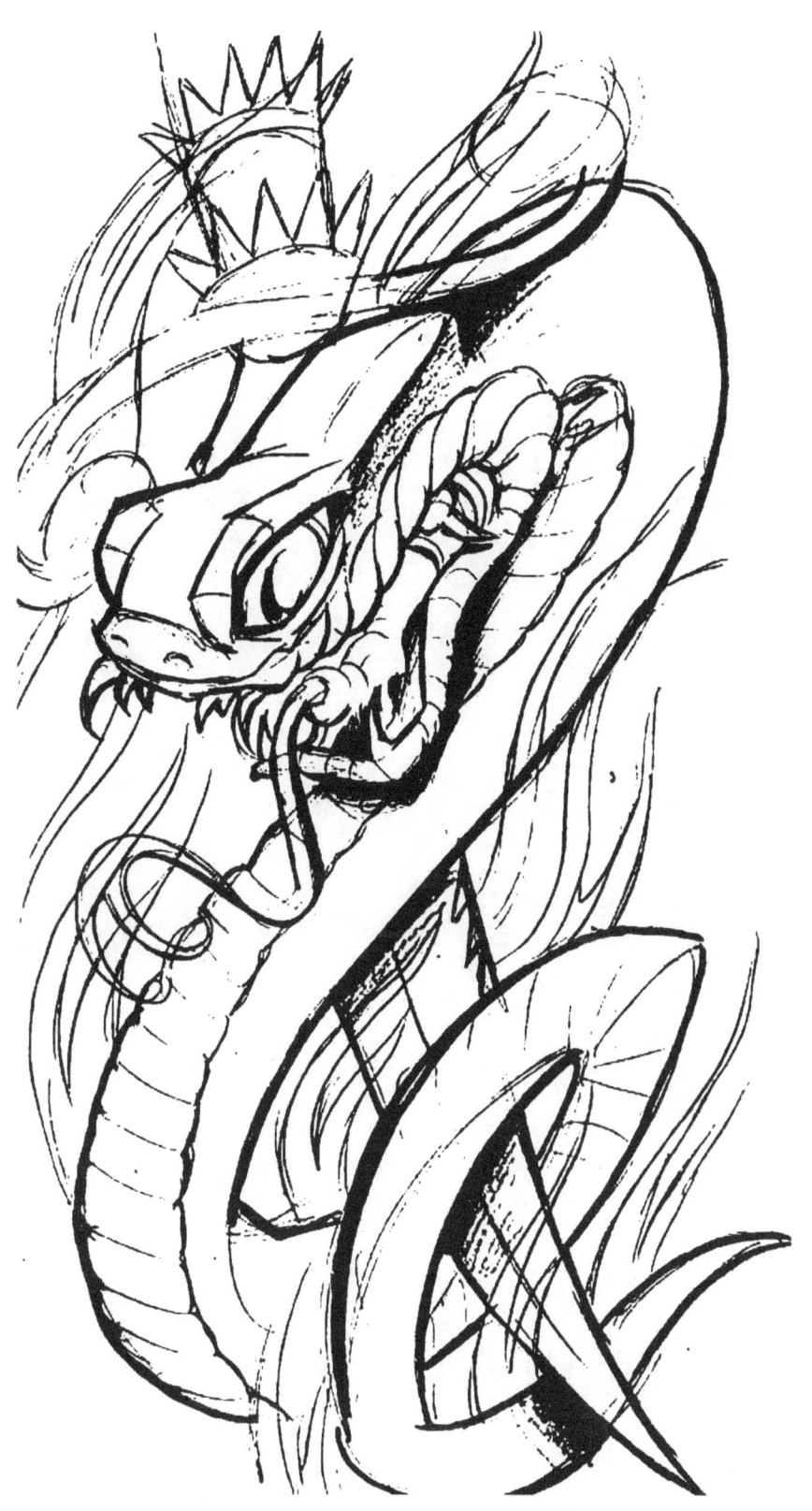

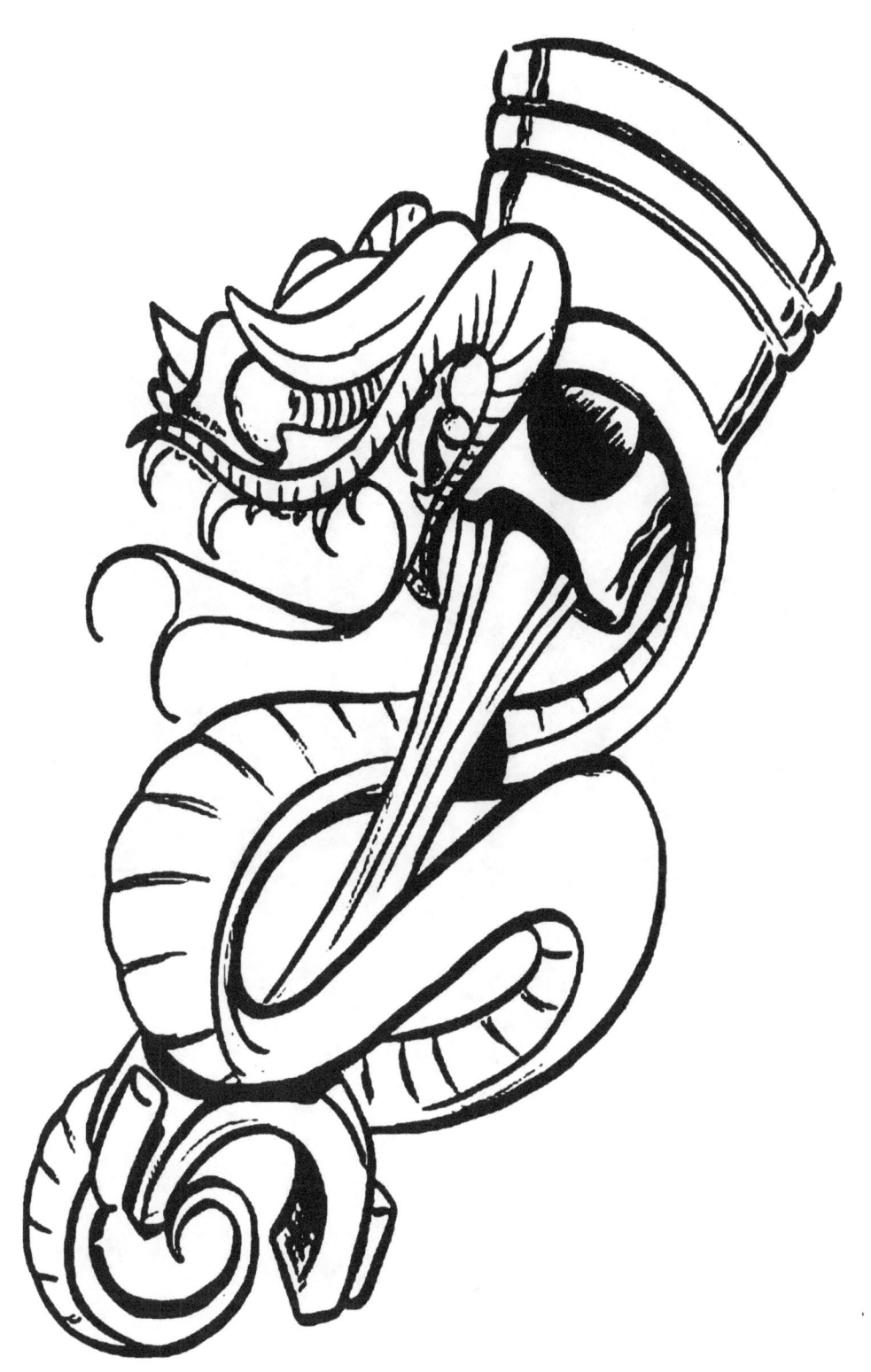

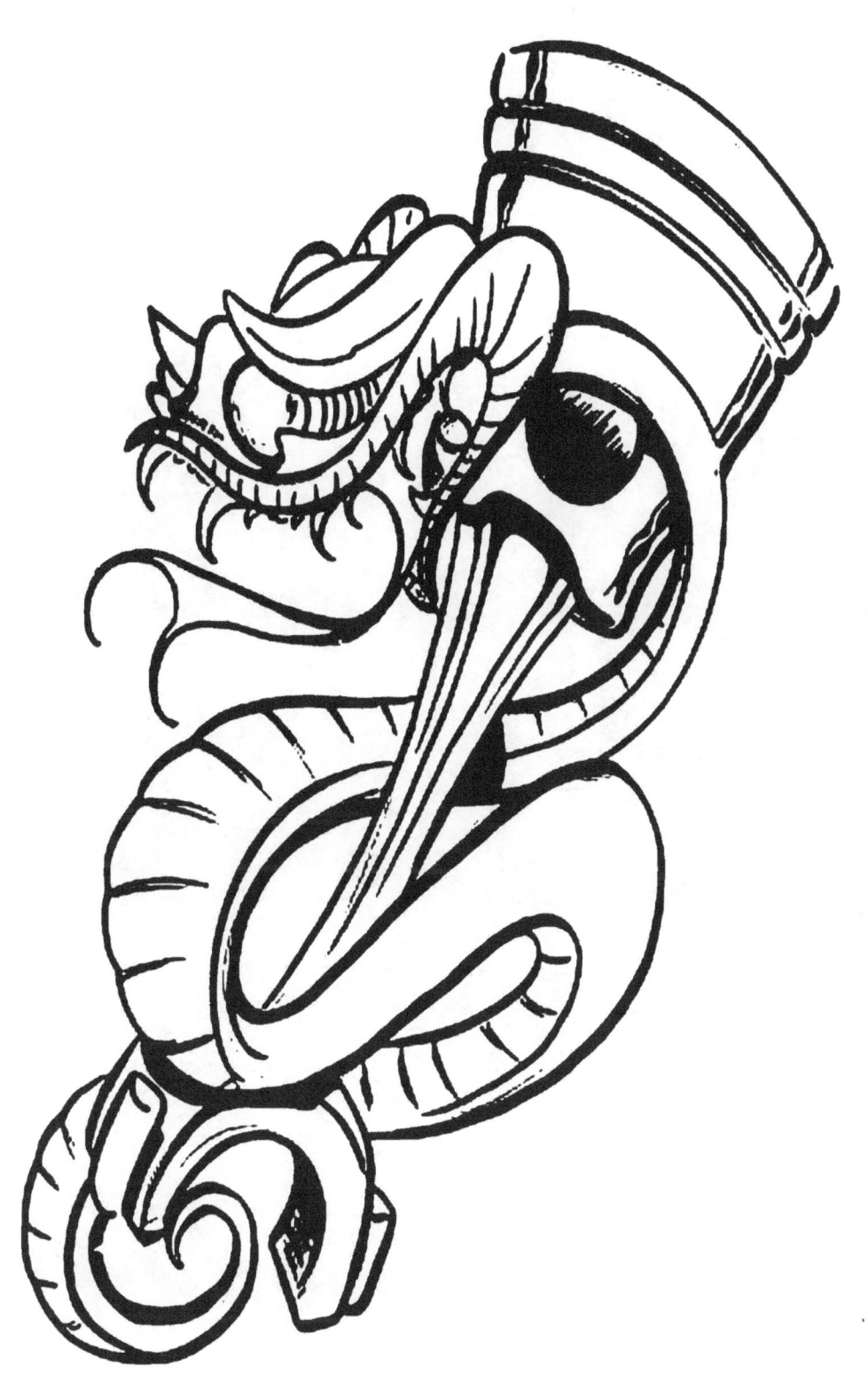

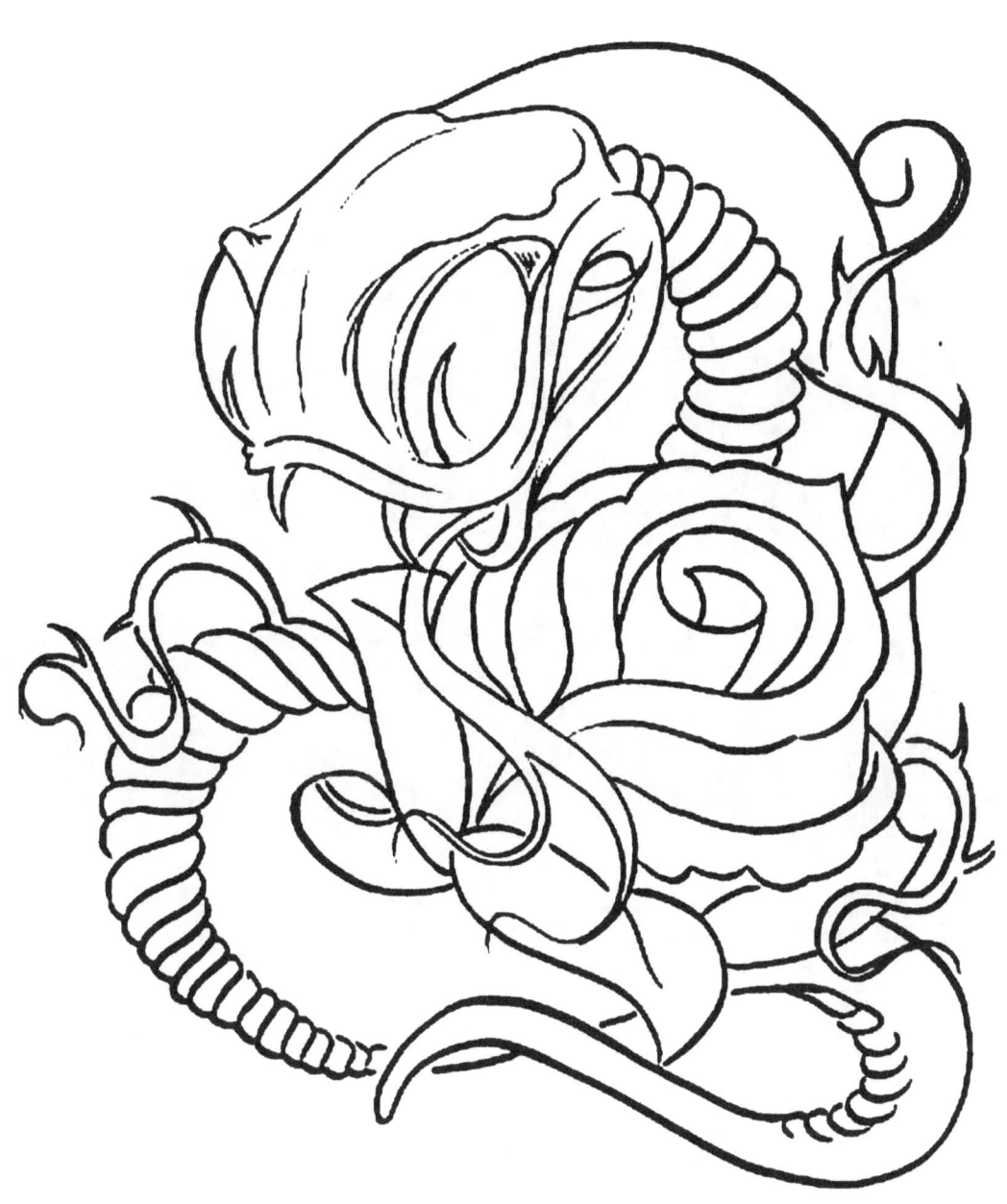

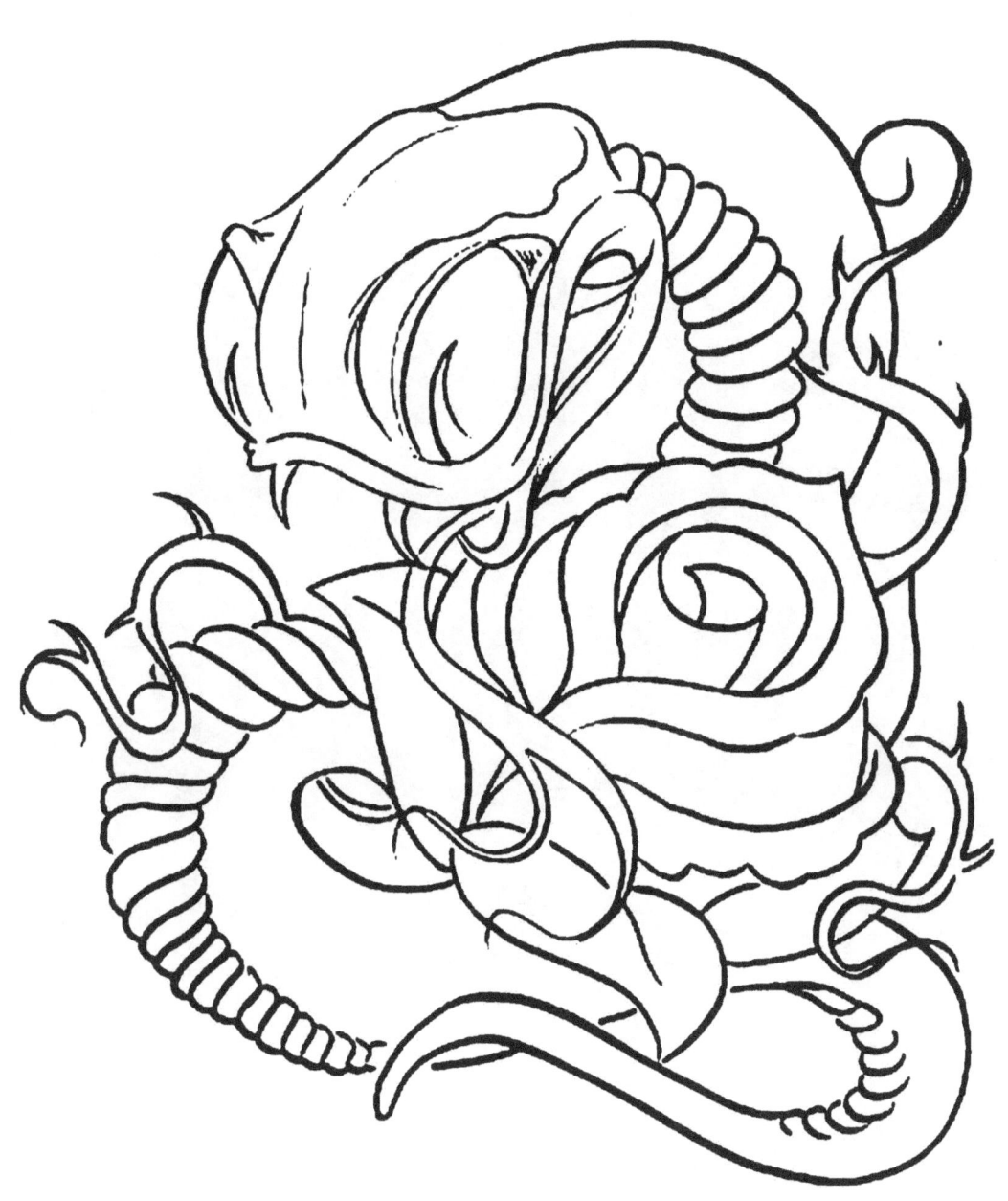

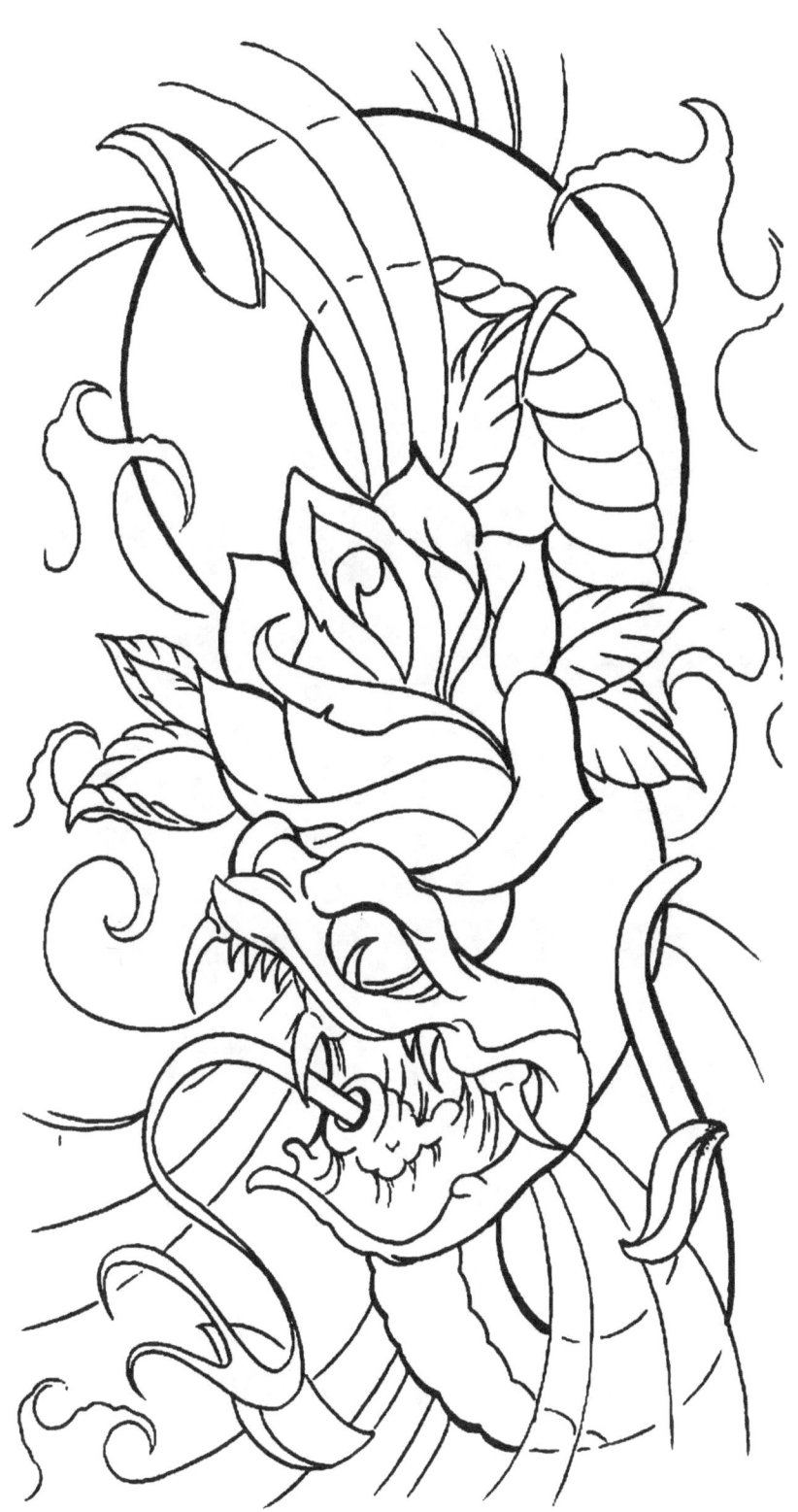

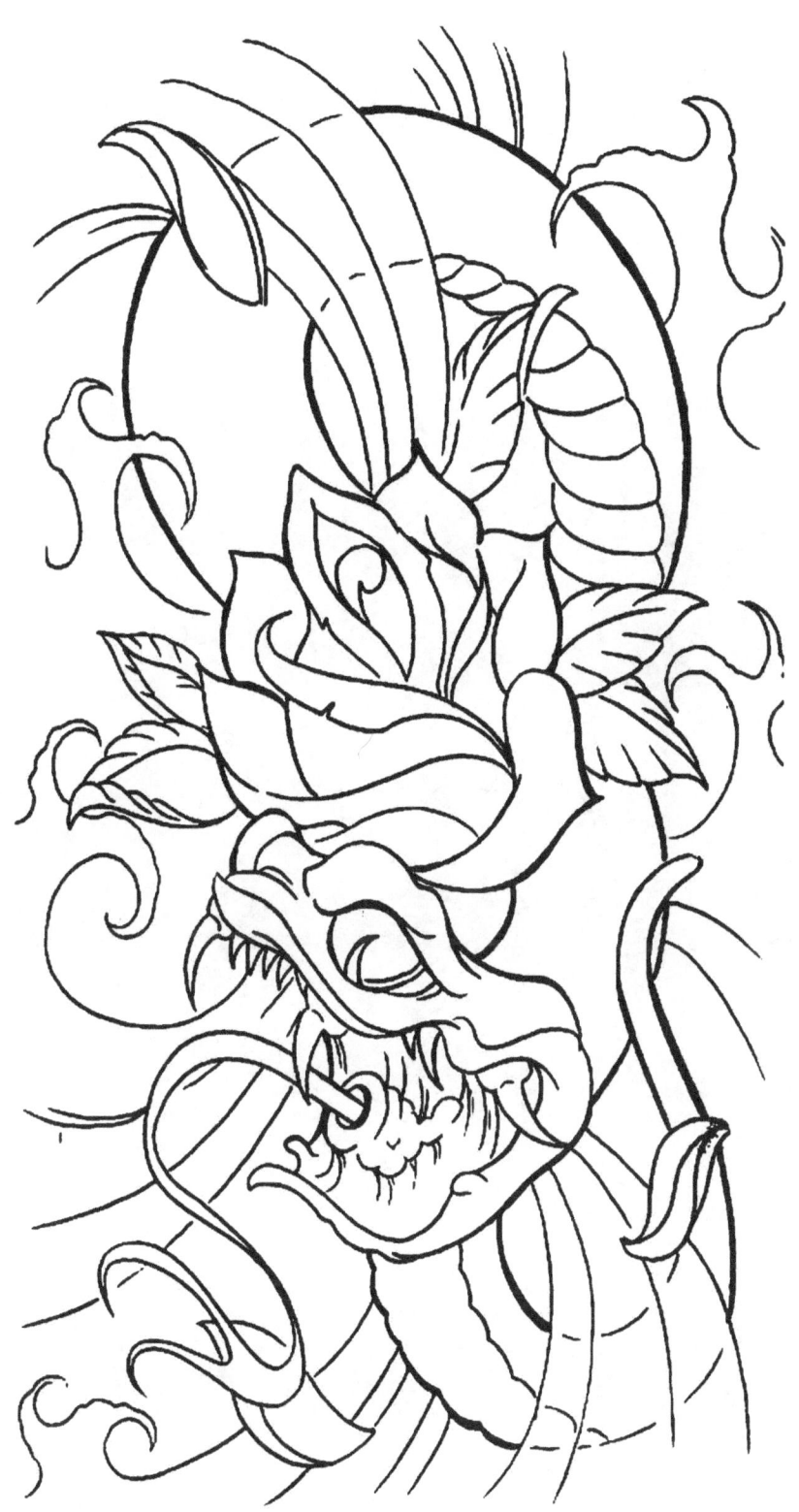

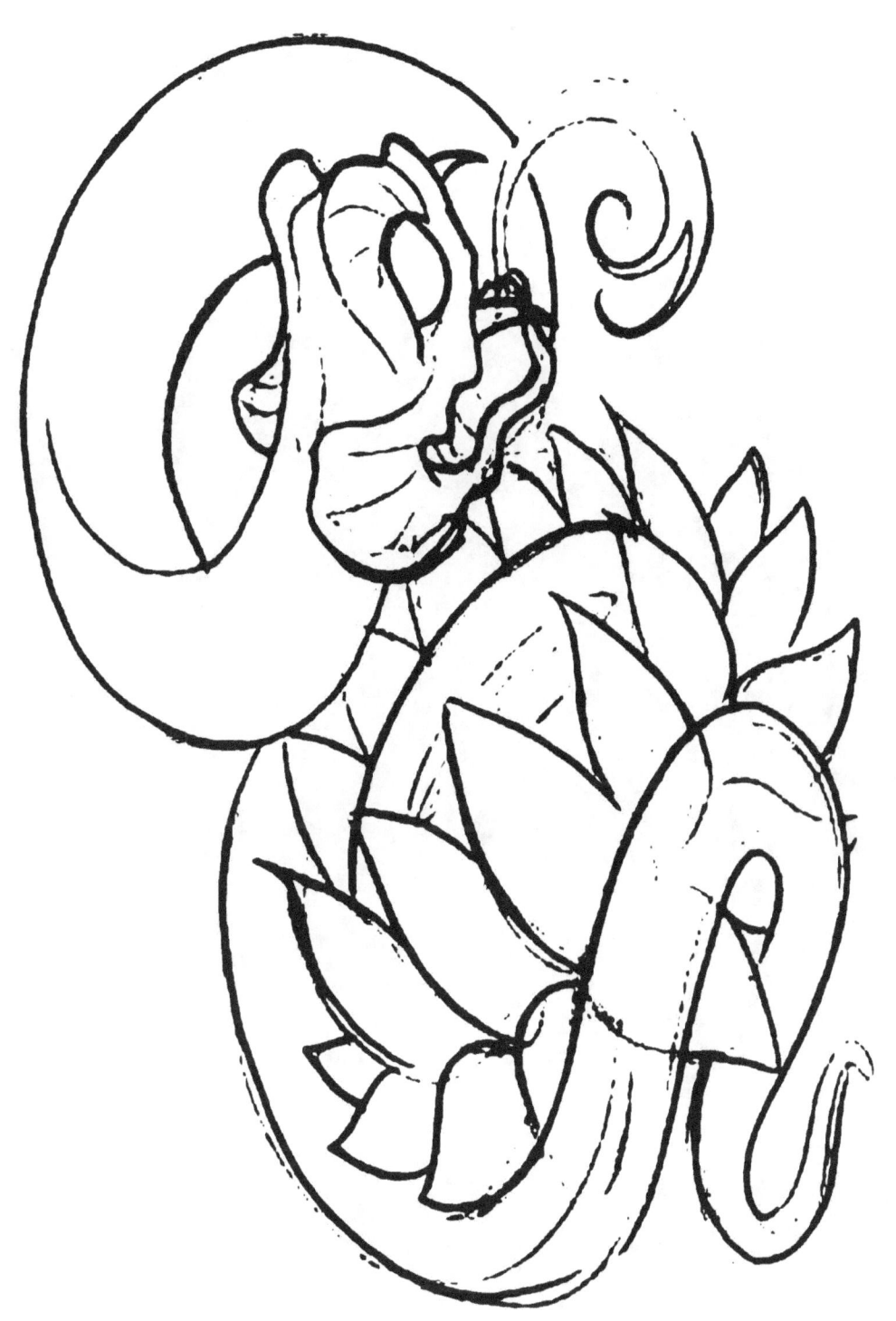

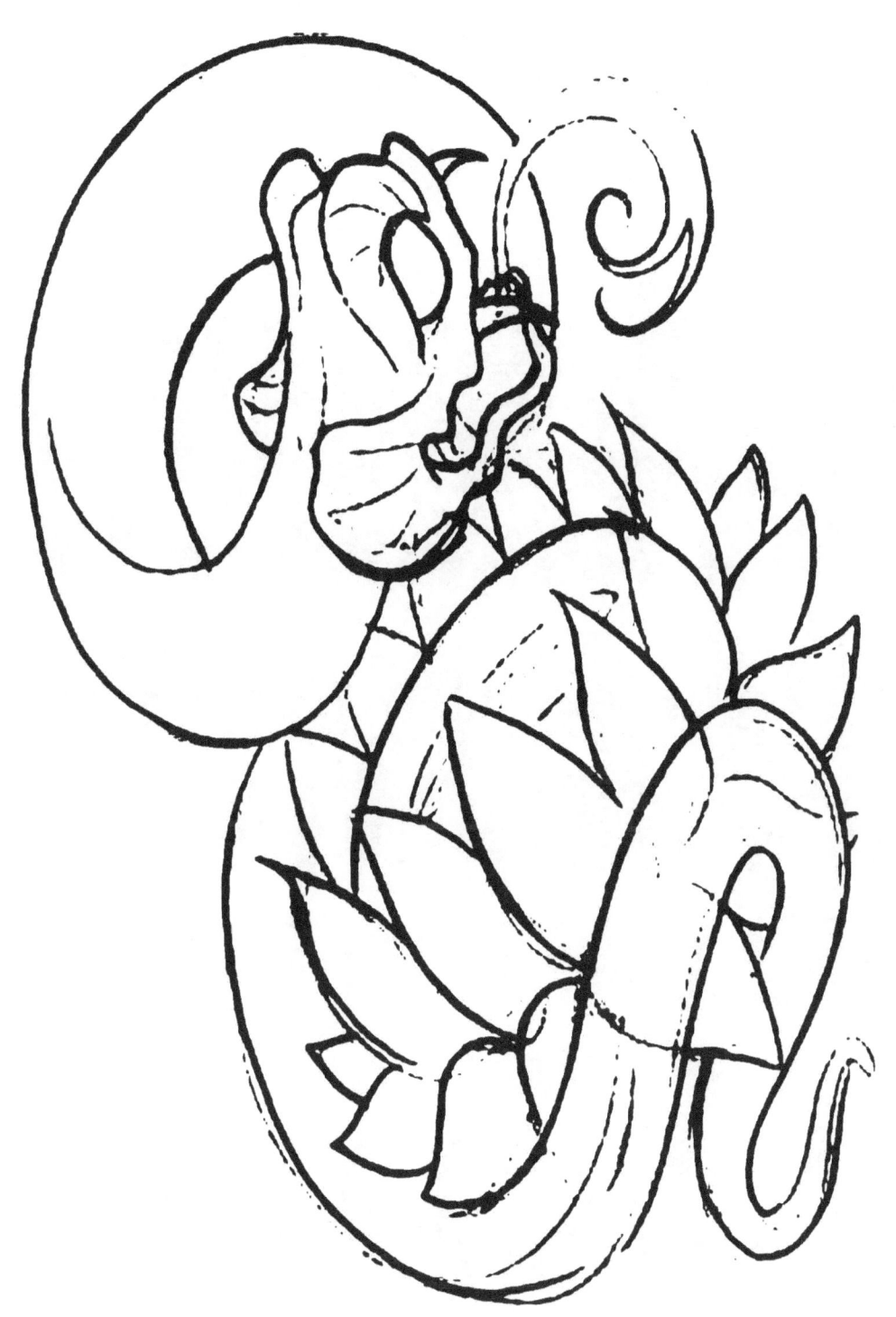

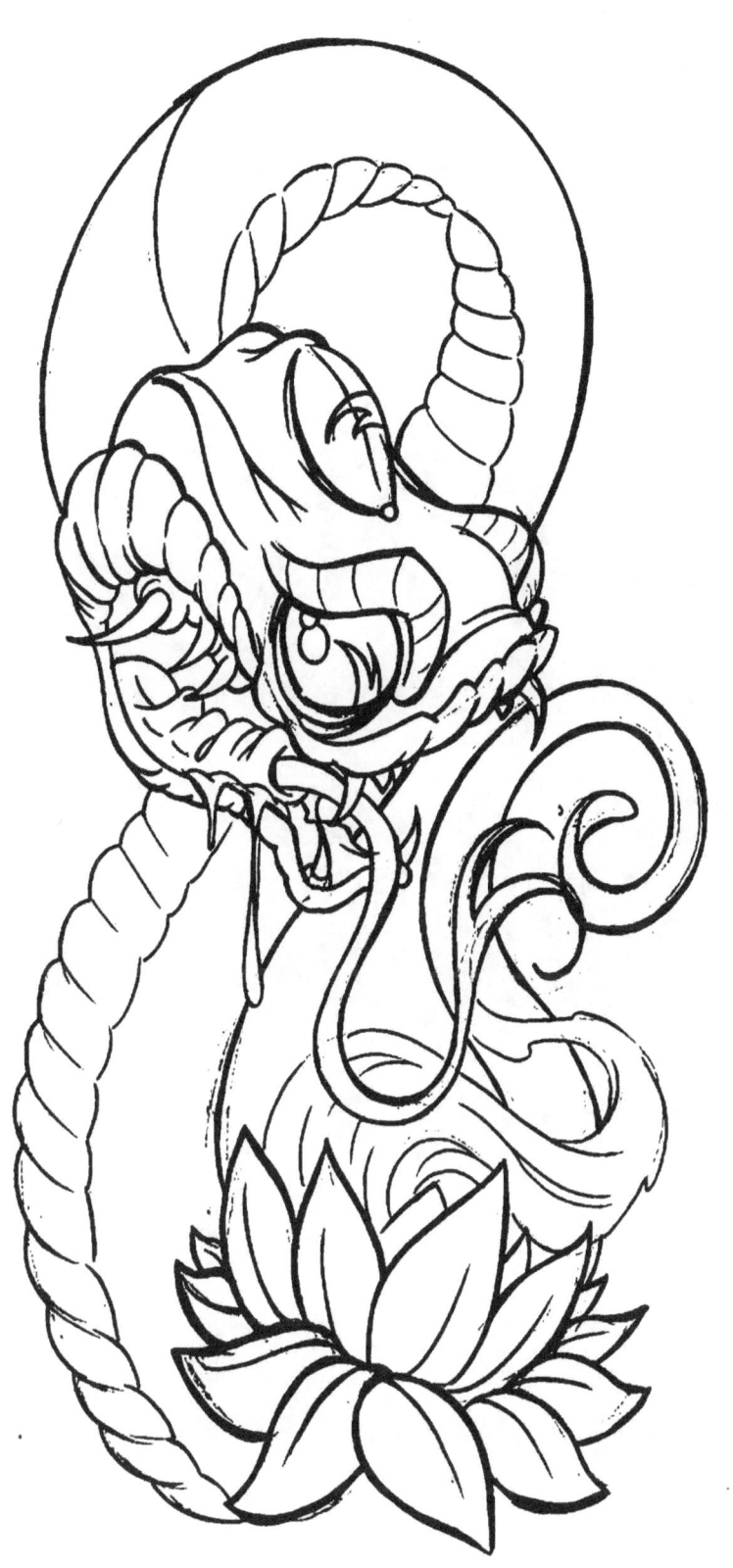

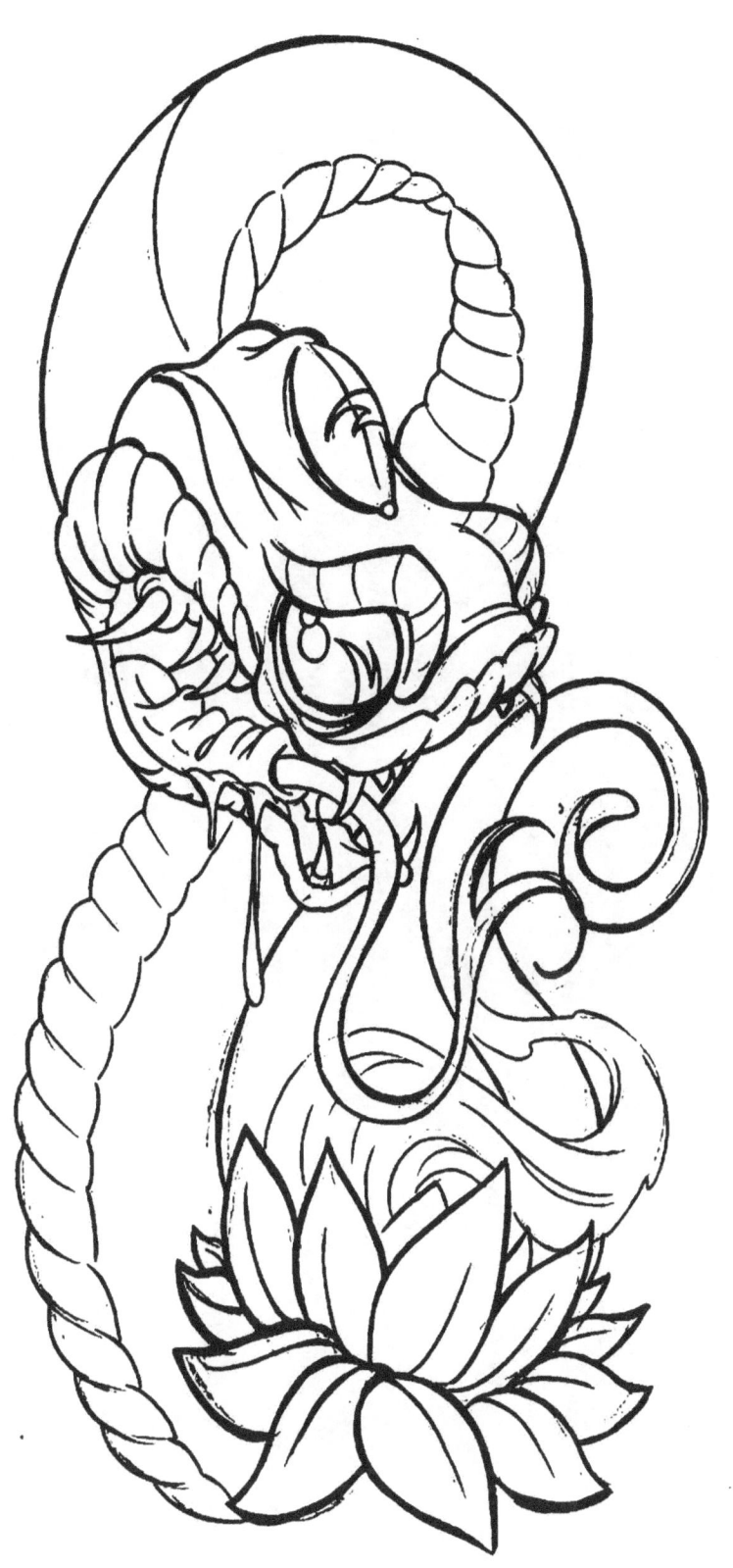

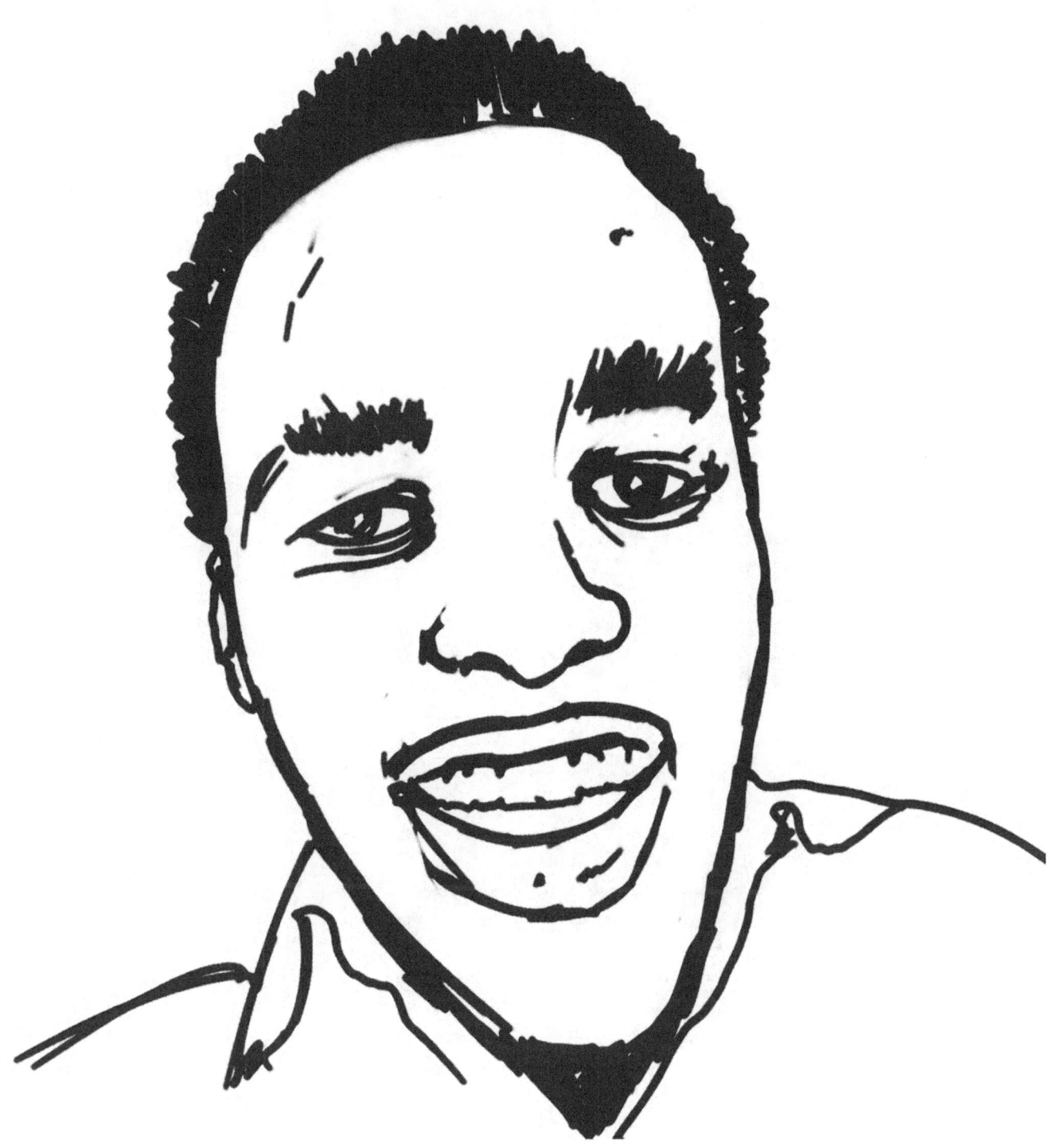

Hi there, my name is Jeff.

I hope you enjoyed this coloring book.

These coloring books are available for immediate download in my etsy shop-jfstudioshop.

If you would like to download individual images don't hesitate to check it out.

Wait!

Yes, there is a bonus page!

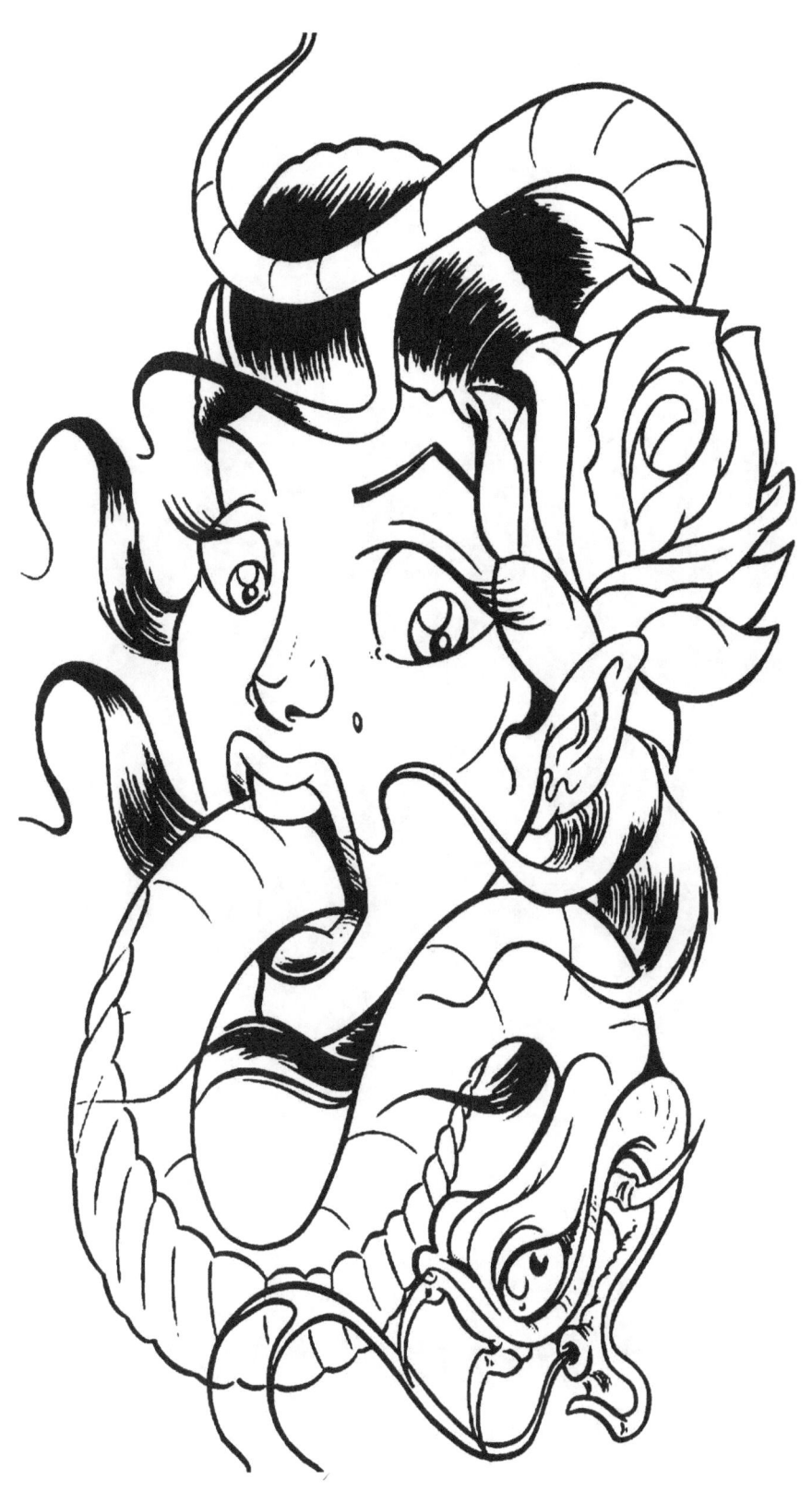

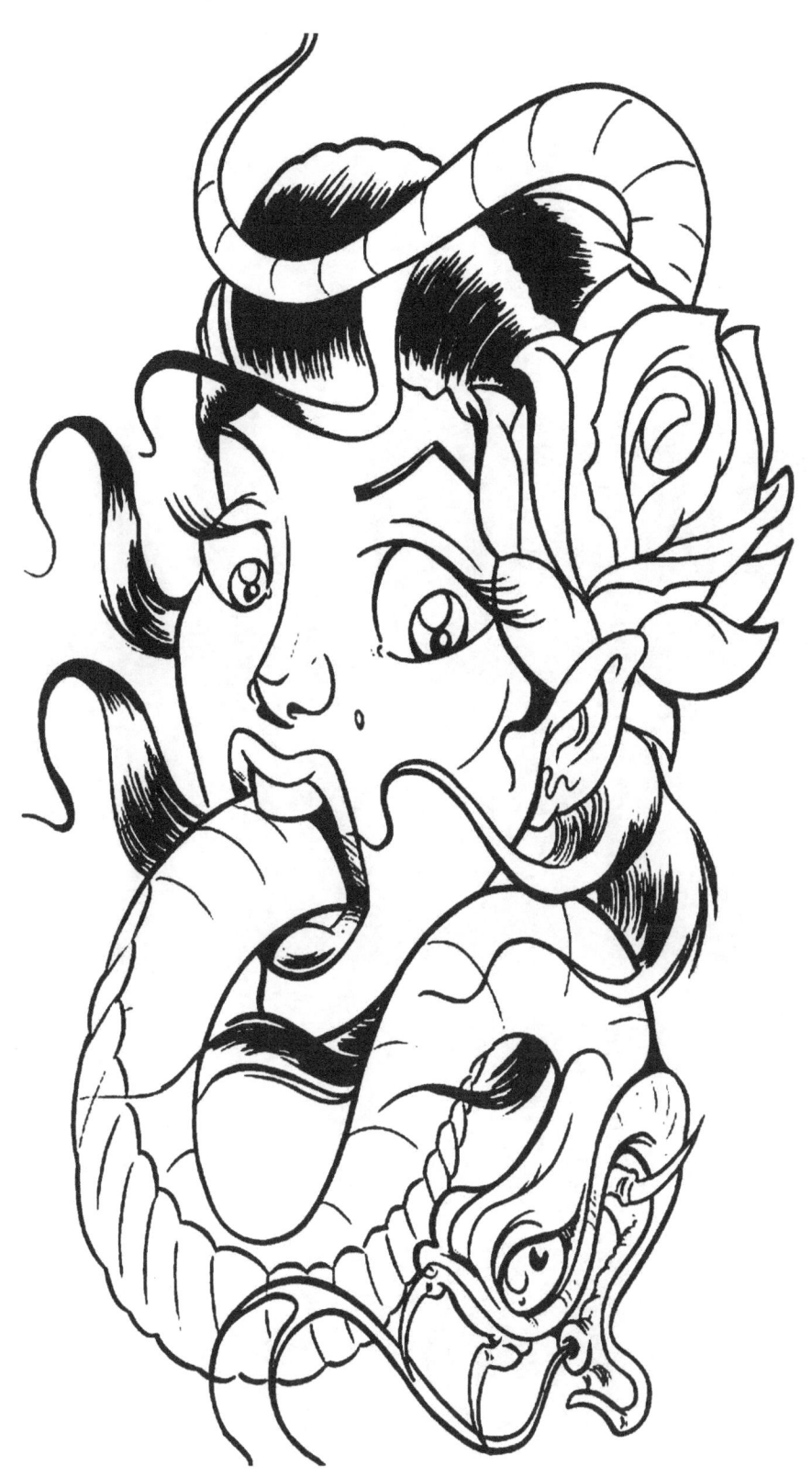

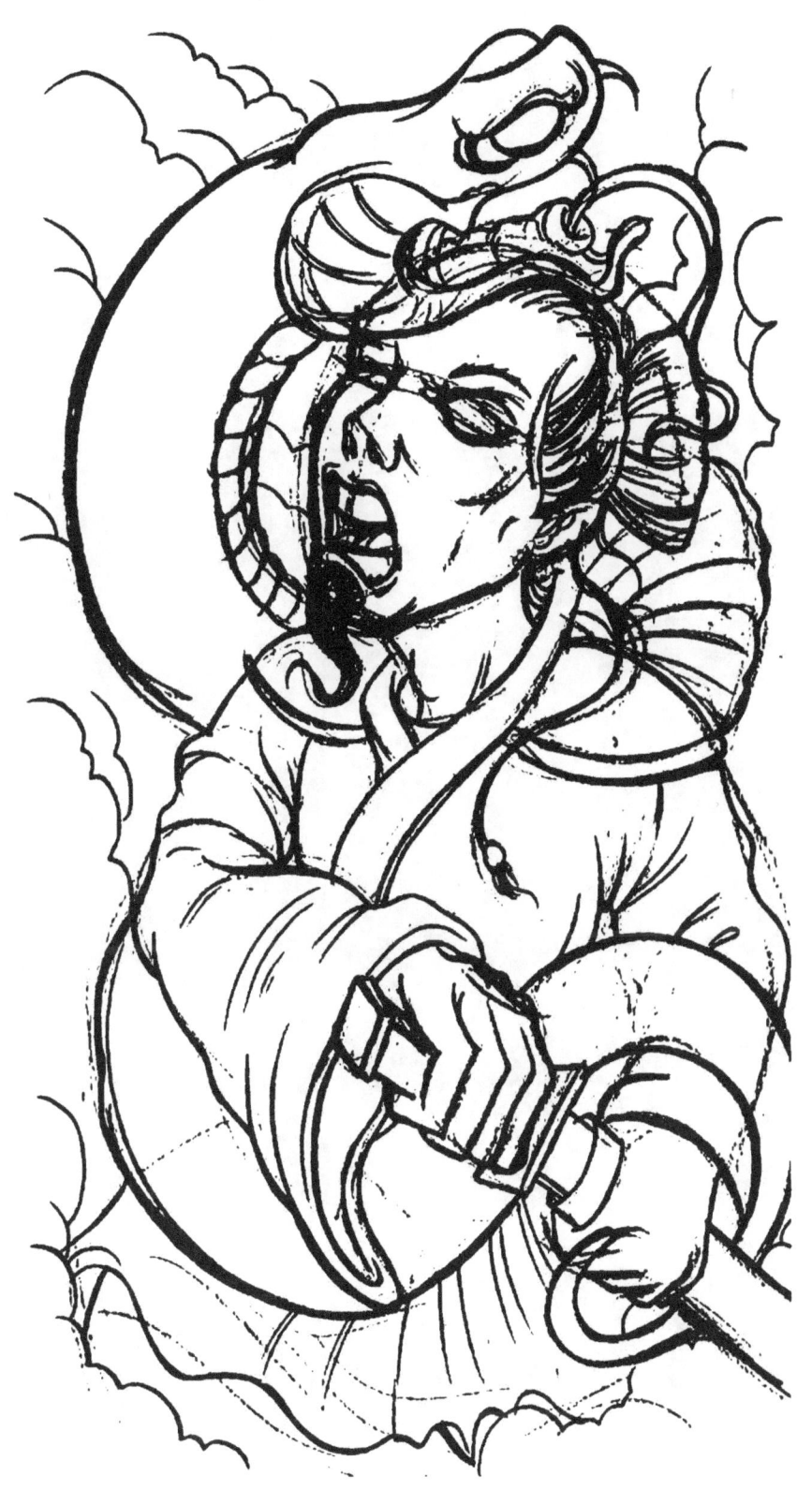

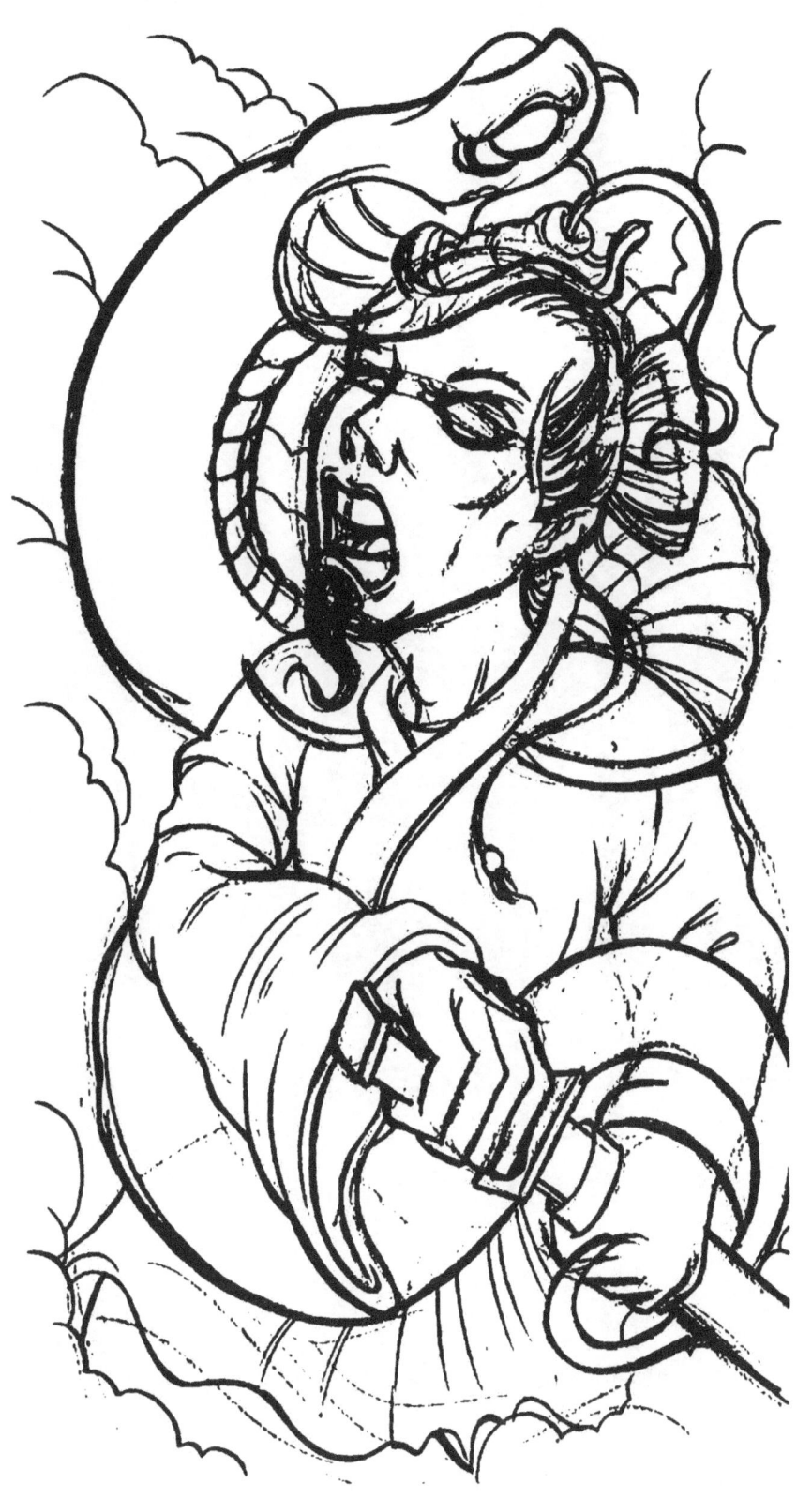

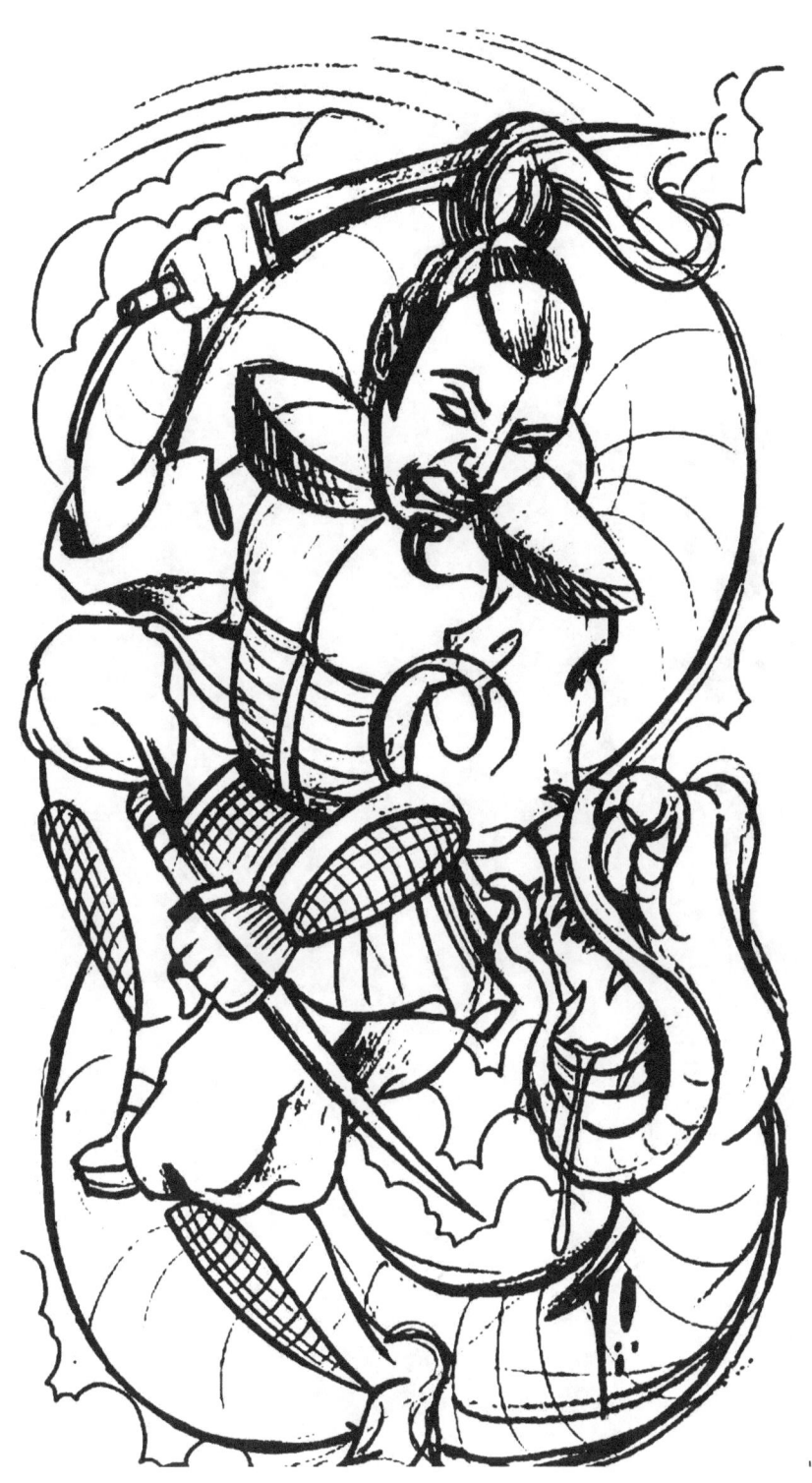

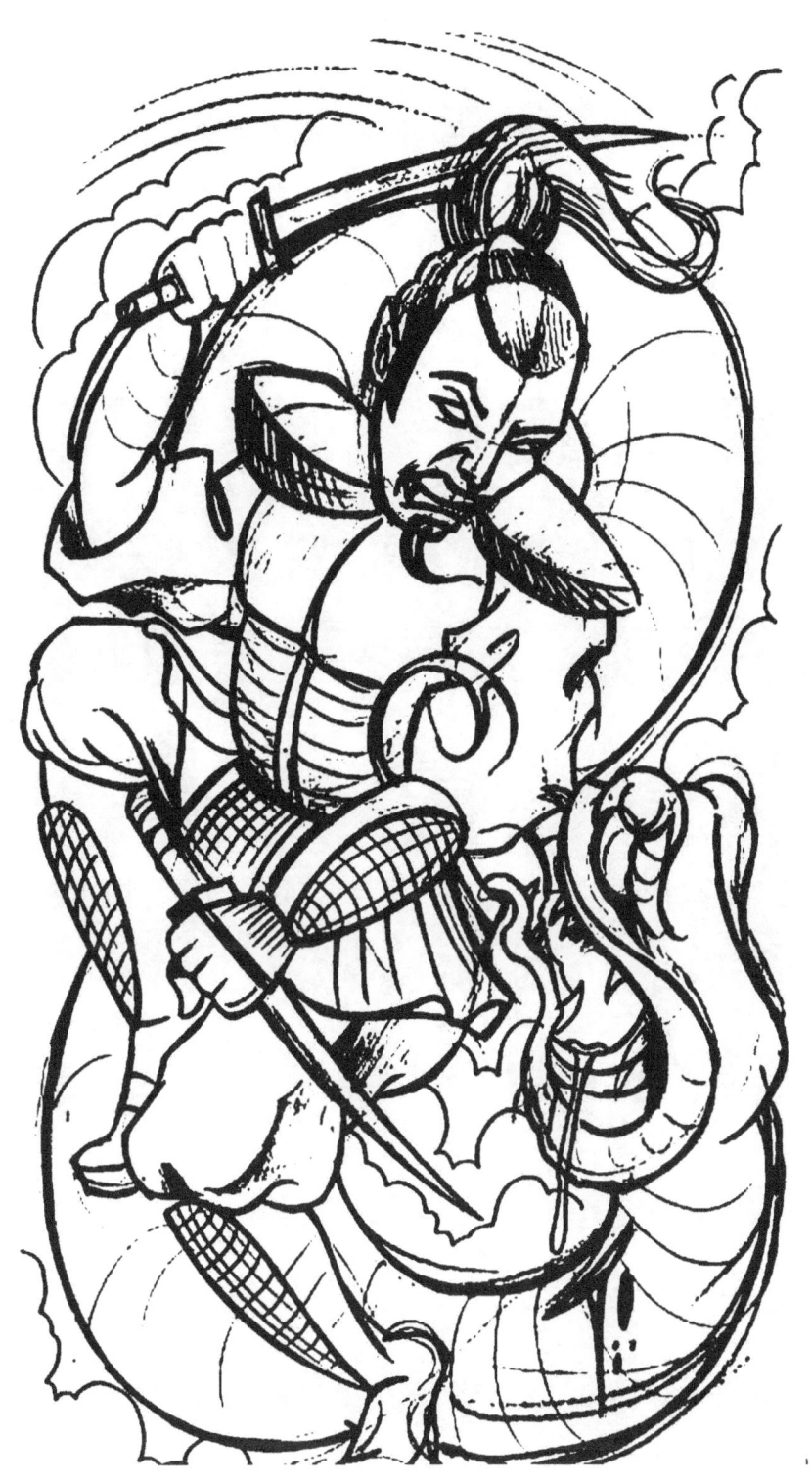

www.ingramcontent.com/pod-product-compliance
Lightning Source LLC
Chambersburg PA
CBHW080622190526
45169CB00009B/3259